PAINT YOURSELF CALM

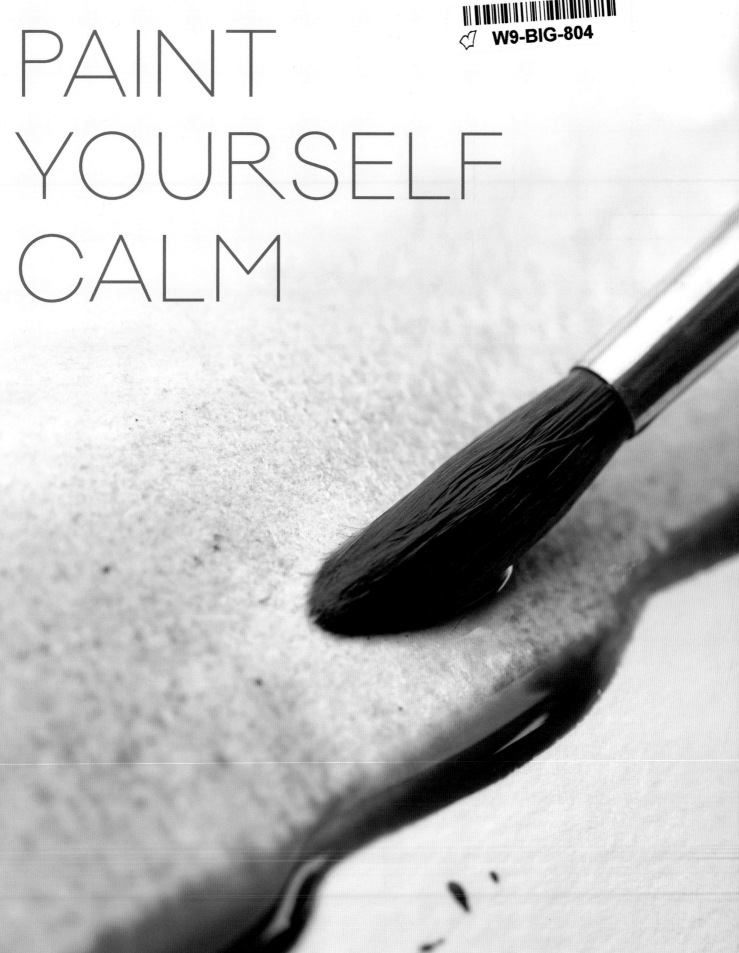

PAINT YOURSELF

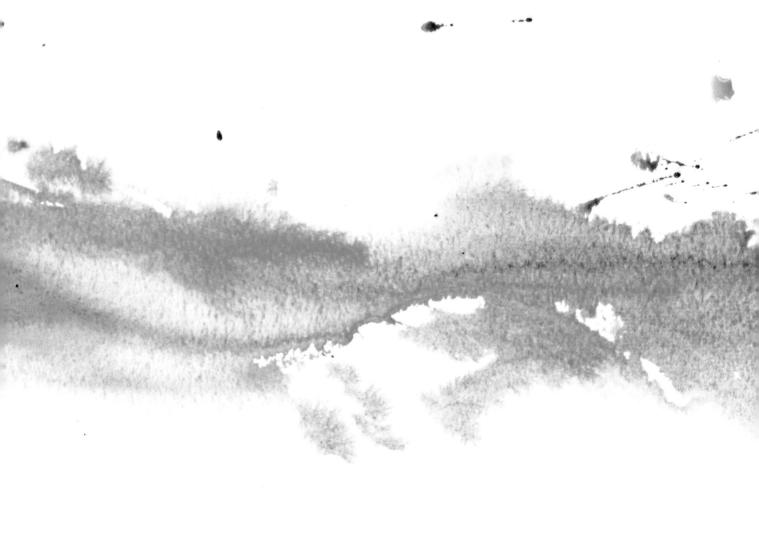

CALM

COLOURFUL, CREATIVE MINDFULNESS THROUGH WATERCOLOUR

JEAN HAINES

SEARCH PRESS

First published in 2016

Search Press Limited
Wellwood, North Farm Road,
Tunbridge Wells, Kent TN2 3DR

Reprinted 2016 (twice)

ISBN: 978-1-78221-282-9

Suppliers
If you have difficulty in obtaining any of the materials and
equipment mentioned in this book, then please visit the
Search Press website for details of suppliers:
www.searchpress.com

Printed in China

To John

My footprints in the sand.

ACKNOWLEDGEMENTS

For helping me with this publication I owe great thanks to so many people. Firstly, to everyone who has encouraged me on my art journey, including all of my wonderful friends and artists who attend my workshops. Each word of support from all over the world has meant so much to me.

Huge grateful thanks go to my incredible publishers, Search Press, especially Caroline de la Bédoyère for seeing within me this exciting new book. Tremendous thanks go to my editor Edward Ralph for his patience and skill in the project of bringing this book to fruition, and to Juan Hayward, whose talented ideas for design seem endless.

Roddy Paine of Roddy Paine Photographic Studios created the most stunning images, capturing each brushstroke with superb timing. I work so fast that his skill is always a thrill to witness in action.

Daniel Smith Art Supplies kindly donated the gems and glorious colours used within this book's pages. I'm thrilled they like my work and am even more thrilled as an artist to use their stunning products.

I have the never-ending support of my wonderful husband John, who really does offer me words of wisdom when needed. Without him I would be lost.

I'd like to mention the best feline art critic ever, dear Buster, who has acted as an amazing companion while I have spent so much time in writing.

But before I close, the most important person I need to thank, the one who plays the biggest role in this new book, is you, the reader. Because without you, there would be no point in writing.

Thank you.

Jean

Author's welcome

'Over the years I have learnt that painting is therapeutic. It calms the soul.'

Life often has a way of leading us in new directions without us knowing. Call it fate, destiny or luck, but here I am, having written a new book which is aimed in a totally new direction from anything I have written before – and I have been guided here by followers of my art, writing and watercolour workshops. Along the way in my career, something magical has been happening besides the skill of painting in watercolour and sharing my passion for this fabulous medium. This new book came about almost by itself. It was not necessarily a single idea so much as being pushed into writing it by an incredible chain of events – and by meeting amazing people, from all over the world, who unwittingly aided my reaching this destination as an author.

My previous books have been step-by-step instructional books on how to paint in watercolour. As I have been writing them, something else has gradually been happening. The feedback I receive about the way I write has been fascinating; several readers felt my art books would sit well in the self-help section of a library or bookshop. Why? Because they are 'feel good' books. Painting from them is an enjoyable experience and I receive messages from readers letting me know how I am changing their lives, not just the way they paint. They are more relaxed and happily overcoming life's obstacles through their new-found love of creating.

I enjoy painting. Actually, that is an understatement. I don't just enjoy it, I adore it and it has changed my life – for the better. Through teaching workshops internationally, I meet people who let me know my work is helping them in so many ways. I will go into this in more detail in the chapters of this new and very different type of publication for me.

One thing I do know and wish to share is that when I paint, I feel different. Whatever has been happening in my life, I can change my mood or feel calm simply by moving a brush. Over the years I have learnt that painting is therapeutic. It calms the soul.

This book is about just that: how to 'paint yourself calm'. How will this affect you and your life? Let's find out by turning the page!

Release
A simple colour flow piece created during a calming painting session.

'When I paint I feel different. Whatever
else has been happening in my life I can
feel calm simply by moving a brush.'

Contents

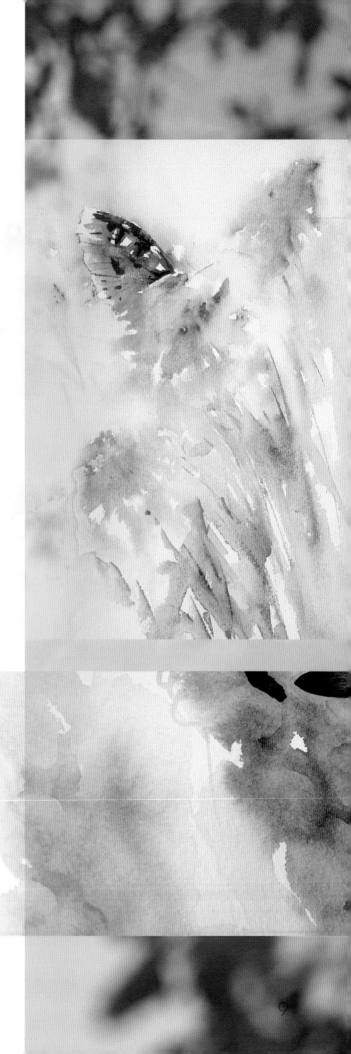

Taking a leap

I stood by the side of the pool at the deep end and looked into the water. My legs felt like jelly and my stomach was in knots. Shaking with fear, I was unable to utter a sound. This had all started just weeks earlier. We had moved to Hong Kong due to my husband's career. Everything was new to me as I had never lived abroad before. Shortly after our arrival we were invited out one weekend for a trip to outlying islands – a popular activity and a great way to relax. A group of friends greeted us on a junk and we headed out. It was such a hot day that everyone else was soon happily diving into the sea to cool down while I could only watch. I listened as my husband explained to one of the other guests on the Chinese boat.

"Jean is terrified of water." He said. He was right. I was.

Ever since childhood I have been scared of swimming. Until that moment I had cleverly avoided any situations where I would be faced with open sea or a pool, but here I was surrounded by people who not only loved but felt at ease in water. One of the ladies present mentioned she taught nervous people how to swim and offered to give me private lessons. I was hesitant at first, but over the following weeks I gradually gained confidence as I learned from her. I moved from small exercises in the shallow end of her pool to more bravely swimming widths. I felt empowered with my new found skill, until the day I was asked if I felt that I could manage jumping into the deep end. I stood for what seemed like ages, staring at what I considered then to be my greatest fear.

I was out of control and maybe that was my biggest hurdle.

I leapt.

As I went downwards everything bad that had happened in my life passed before my eyes. I felt as though I was watching a movie, but strangely each memory lifted from my shoulders in a way that added to my new found sense of freedom. I was letting go of the past.

Years later the memory of that day is still with me – I had almost forgotten all about it, until the lady who taught me to overcome my fears was standing by my side in my art studio. Now a long-time friend she has helped me to overcome many hurdles in my life. I heard her repeat what I had said when she first taught me to swim.

"I can't do it," she explained. "I want to but I can't – I'm afraid."

Ann and me in Thailand
Painting with the friend who taught me to swim.

Unbelievably to me, my dear friend was talking about painting. It was my turn to take away a fear. I explained how magical the experience of painting is and how it has changed my life. It has been a rock in times of trouble. It has helped me overcome many difficulties when needed, simply by moving a brush. I have travelled to and lived in new countries where I haven't known a soul and made new friends by sharing my passion for painting. I have faced the fear of cancer, the sadness of bereavement and loss. I have known stress for the variety of reasons that is life. Each time, by picking up a brush and simply watching colour flow I have lifted my spirits and changed my mood. It has been a form of therapeutic escape, and is now a very healthy addiction as well as an unexpected wonderful career for me.

The reason for my new book was born; just like that.

I am sharing how to paint yourself calm

... and to enjoy doing so!

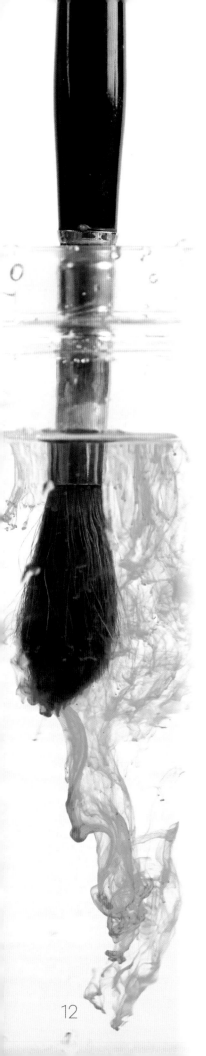

Anyone can paint

'Everyone can escape from stressful life situations to find inner peace, simply by playing with colour.'

Strangely, painting as an activity seems to be a stressful suggestion to many adults – yet as children it could often be viewed as one of our most pleasurable ways to pass time. What happens when we grow up? Do we simply become more serious and lose that youthful sense of adventure?

Perhaps as adults, we come to feel that everything we do in life has to have a recognisable goal to work towards, or carry a sense of achievement. This puts weight on our shoulders – and then the activity can become a chore, something that has to be done and done well.

In art, this way of thinking can affect how we feel when moving a paintbrush. Before we even pick it up we may feel immense pressure as our initial high expectations of the finished result play on our minds; leading to disappointment if we fail. No one likes to feel as though they are a failure in life.

The myth

A myth exists that when we paint, we have to produce something worth seeing, and there is a weird notion that we have to be worthy of holding a paintbrush. It sounds crazy, but I meet people who tell me, with the greatest of conviction, that they aren't good enough to paint. The question is – good enough for whom?

Painting is not solely about creating a painting that is good enough for sharing with friends or hanging on a wall. Sadly, that is how art is seen by many. Painting can be so much more. It can be a way of life. It can certainly be viewed as a career. But even professional artists can feel the stress of needing to succeed. In this book I am heading away from stress and into a world of peaceful calm which can lead to the highest of highs, for anyone and everyone – including you.

Pressure

Obstacles formed in colour.

'Weights we place on our own shoulders - of having to succeed in life - not only hold us back but also prevent us from enjoying many experiences that could enrich our lives and add to our feeling of self-worth.'

The truth

The emphasis should lie in your feelings while creating – the joy of simply watching colour flow across paper without any goal of it leading to a masterpiece can be totally invigorating; a sensation lost to those scared to pick up a brush, and completely out of reach for those who feel painting is for artists or for people with talent alone. This simply isn't true.

Anyone can paint. Not only anyone, but everyone – of all ages – can escape from stressful life situations and find inner peace simply by playing with colour. This is what I intend to focus on in this book.

'Anyone can paint. Not only anyone, but everyone.'

The action

In painting, the action is as important as any finished masterpiece. Putting the emphasis on what you paint, not how you paint, places unnecessary stress on you. We all need to discover a way to look at the incredible experience of painting in a way that pleases the soul. People of all ages, from all walks of life and all over the world, are already loving the time they spend painting. They frequently feel energised or younger from the experience.

Feeling curious about something and having the courage to try it is very different from standing quietly and watching others enjoy themselves. Those who do paint understand that the art world is an incredible sanctum where people with all kinds of abilities create simply because of the pleasure it gives them. They can make new friends if they wish to by joining an art society, or they can paint alone, passing time calmly. They can feel a sense of accomplishment too, not only by producing a painting, but through the action of painting itself.

Life-changing

I feel a sense of calm when I paint, and this is evident in my workshops. What is more, I constantly receive messages from people who have attended my courses, letting me know how painting is changing their lives. They feel more relaxed, happier and younger than they have in years. They gain patience; they see things differently.

When you are painting, it is possible to temporarily forget what is happening and to be drawn into a wonderful world of colour, where nothing else matters. While we are in this private world, it doesn't. All that matters is that you – the one holding the brush – are happy.

And that's not a bad way to feel, is it?

Unknown

Making discoveries at any stage in our lives can be thrilling. Painting may not be seen in the same light as bungee jumping, for example, but it can still lead to the most incredible of 'highs'. It can bring a euphoria which cannot be described in words alone.

Happy

Why you should paint

'We can learn to feel energised or able to relax, simply by moving a brush.'

Why should you paint? That is a really good question, but I prefer to ask 'Why not?' As mentioned in the previous chapter, painting is not just about producing art. It can be great fun and is an excellent way to pass time peacefully. Many people also find painting an incredible form of therapy, mainly because it can be a wonderfully relaxing experience. It would be wrong not to mention that some people find painting stressful because they set their expectations on what they wish to achieve far too high, but the goal of this book is to learn to paint in a way that helps you feel calm.

As the reader, you could be completely new to painting or a professional artist who feels stressed each time they create. Unlike a sport, anyone can paint. You don't need to be super healthy or of a certain age, because painting is something that you can do at any time in your life. The beauty of painting is the fact that you don't have to aim at being a master. Not everything we paint needs to be framed. It is the process that is wonderful. Just playing with colour alone can be really satisfying. It can be fun, rewarding and, believe it or not, exciting; in a way that can become addictive – a very healthy form of addiction, I may add. As far as time goes, you can paint as little or as often as you wish.

'You do not have to be good at art to enjoy painting.'

Art has an unnecessary image of people having to be brilliant at it to pursue it, which is so sad. We can kill that myth here and now – you do not have to be good at art to enjoy painting.

Opposite:
Blues of Summer
28 x 38cm (11 x 15in)

No one would claim that gardening is only to be enjoyed by experienced gardeners. In the same way, painting can be enjoyed by everyone. The experience of painting – not just the outcome – can bring great pleasure in life.

Why paint?

Control

'Having the ability to say where, when and how you paint is empowering.'

Life is often stressful and our daily routines can often be tiresome, but when you paint, each day can hold something new to look forward to. You can use new colours or new techniques or try to paint new subjects if you wish. You have control. That is a key word.

When so much of our lives is out of our control, having the ability to say where, when and how you paint is empowering. The achievement is gained by picking up the brush – and in using it to enjoy the experience rather than the result. I will show you ways to do so later in this book. Before that, let us look at some other reasons why painting can be good for you and your health.

Stress relief

'Eventually you will find that you can calm your mood simply by thinking about painting.'

It is possible to calm down by placing our focus solely on painting with soothing colour. Moving a brush gently and watching as pigment glides across paper is one of the most peaceful activities you can enjoy.

As part of a daily routine, looking forward to painting simple colour exercises – even for a few minutes – can reduce stress. Deliberately setting time aside to be calm can have a knock-on effect, in that eventually you will find that you can calm your mood simply by thinking about painting in certain colours – even if you do not have the time to physically pick up a brush.

Helping others

'The happier we are, the happier are the people around us.'

Sometimes we are aware of situations that distress us. I use my art as an outlet to release any feelings that may make me feel sad. I also know that I can cheer people up with my paintings. For this reason, painting not only calms our own lives, but gives us the power to make someone else smile. That is pretty wonderful too. The happier we are, the happier are the people around us. Painting yourself calm can have a ripple effect on those close to us – we calm them too.

Solace

'You are never really alone when you paint. Colour can become your companion.'

While you can paint in the comfort of your own home, you are never really alone when you paint. Colour can become your companion in a way that I had not truly appreciated until I started teaching workshops and writing this book.

The pleasure painting brings can ease a sense of loss or loneliness. I have met many wonderful people going through a bereavement who turned to art as a way of getting over their loss, and found comfort in doing so.

A form of escape

'There is an understanding that when artists paint they leap into a private world where nothing else exists.'

When we are faced with obstacles or things are going badly wrong in our lives, painting is an activity that can be turned to as an instant form of escape, and to give a calming sense of comfort when needed.

There is an understanding that when artists paint they leap into a private world where nothing else exists. This is true for me. I could be on another planet where only I am living. It is a planet of my creation. It is peaceful, full of beauty and nothing bad ever happens there. It is my idea of heaven. You can create your own planet too. One that fills you with happiness and joy, and makes you feel calm.

The Journey
Painting in blue – easy, relaxing and calming.

My personal journey

Life-changing

'In every step of my life, my art has helped me get over hurdles that I cannot imagine climbing over without the comfort of working in colour.'

Without a doubt, painting can be life-changing. As crazy as this statement may seem, it can. I am a prime example. As an energetic person who finds it almost impossible to sit still, art is the one thing that has calmed me down in life. When there has been a crisis I have turned to painting. When I have been in tears due to bereavement or loss, I have turned to painting. When I have wished to celebrate I have also turned to my art.

I have moved so many times to live in different countries where I haven't known a soul, and made friends who love to paint. I have gained confidence as my skill has grown. I have made a successful career out of what I do each day. But one thing has never changed. The little girl who escaped from the sadness of her parents separating and being taken from her mother at a young age has grown into a very warm-hearted, generous person who cares deeply about others.

In every step of my life, my art has helped me get over hurdles that I cannot imagine climbing over without the comfort of working in colour. Which brings me back to you, the reader.

Can you paint yourself calm?

Please remember that you don't have to be good at art. You don't have to be talented. You just need to be open-minded to enjoy what is happening in front of you on the paper. More importantly, you need to learn to feel what is happening to you, your mind and your body while you create.

Painting to feel calm can help you to find inner peace; to relax as you would in a yoga class or even a health spa. Without leaving your home you can take yourself into another state of mind, simply by painting. That is really an awesome thought, isn't it?

Mood changing

'The calming influence on our emotions when painting can be quite incredible.'

It is very hard to explain why simply moving a brush can change your mood but it most definitely can – especially if you have no pressure on your shoulders to produce a masterpiece whilst creating.

Painting is an activity that requires very little in the way of energy and can be a most relaxing and rewarding way to pass time. I believe more people are taking up art than ever before because of the wide variety of ways to do so. It is an accessible hobby that can lead to meeting other like-minded people should you join art clubs or societies. But for many, the choice to paint quietly at home without sharing what is created is enough.

What happens when we paint?

When painting, we can become distracted from everything that is happening around us as our focus is held by what is happening in front of us. In watercolour, simply watching colour flow across paper brings its own sense of satisfaction.

Painting is a pleasurable experience that can be so simple. Its calming influence on our emotions can be quite incredible – an experience hard to explain in words. I hope to share the peaceful feeling and joy I experience when I am working with colour through the demonstrations later in the book.

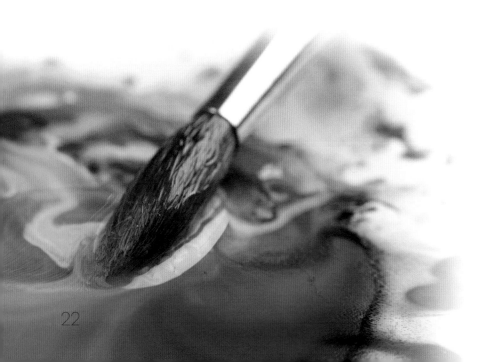

Energy

Green is the colour we link to nature. A colour that is
often used by interior designers to create a calm room,
green can be refreshingly energising to paint with, in any
style or art technique.

We can change our mood

Our moods are often affected by the seasons. I love the warm summer months, but feel like hibernating in winter even though it too holds some very special qualities, like fresh snowfall. When painting, it is possible to leap ahead to spring while rain or snow falls outside, through our choice of colour. To be honest, having a subject is often irrelevant: the joy is simply in painting – the action of moving the brush and absorbing the energy from the colour used.

Leaping Towards Spring
You can use paint to forget dull dark winter days, or days when things have not quite gone to plan.

Whether we are painting to feel in control or to relinquish that control, we can change our mood. It is sadly not always possible to find the positives in a bleak situation, but painting can sometimes offer an escape.

As a child, I was given crayons and paper by my grandparents and sat at a huge table to draw. I became fascinated by what I could create by moving the fat stubby sticks of colour. I may not have been allowed to pick the flowers in the garden or own the dog I yearned for – but I quickly learned that I could have these things by drawing them: art could bring me anything I wished for. I learned I could make myself happy through painting. It is an ability for which I am very grateful.

Changing our mood through painting is awesome. Whatever is happening
elsewhere in our lives, it gives us power and self-worth. As an adult, I moved
many times with my husband, living in one country after another. Each time
I looked for art classes in my new life so that I could paint and meet people
who also enjoyed creating, and also escape loneliness in a new place.
Painting became a lifeline. I will share how it has changed my mood and
lifted my spirits on so many occasions with the following exercises.
What I have learned is that now I know how to paint using simple colour
exercises, I can escape, paint on my own and feel perfectly happy
whenever I want to, and wherever I happen to be.

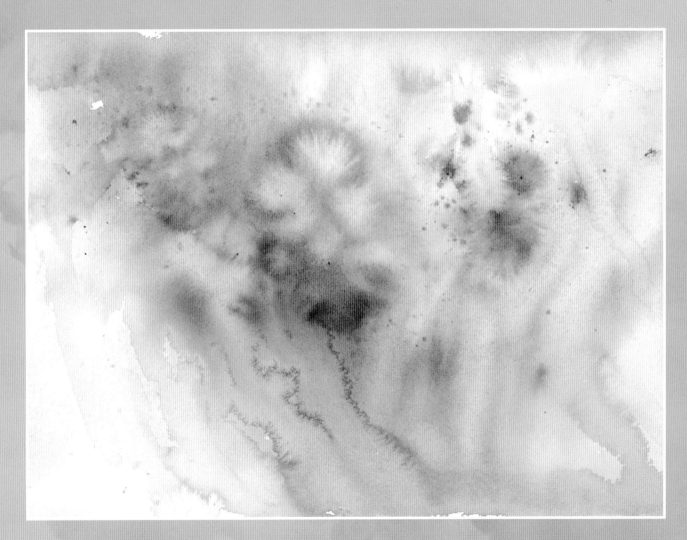

Colour Bursts

Positive energy flowing through an abstract wash. Painting techniques can be used to
relax when painting. This is a very simple way to calm down, lift your spirits or feel good.
It is an opportunity to lose all negativity and instead place the focus on being happy.

'Life is like a white piece of, paper waiting to be painted.'

On this journey, page by page, I will share how painting can affect our mood and make us feel different: energised, happy, calm, relaxed and refreshed. I take the happiness from one day and allow it to flow into the next; learning from the day that has passed and taking the good into the new, while leaving anything that didn't work out way behind me.

Life is like a white piece of paper waiting to be painted. We have the choice of how we paint it. I am going to choose to paint mine 'calmingly colourful'.

To get started we need a few materials. So, on to the next chapter.

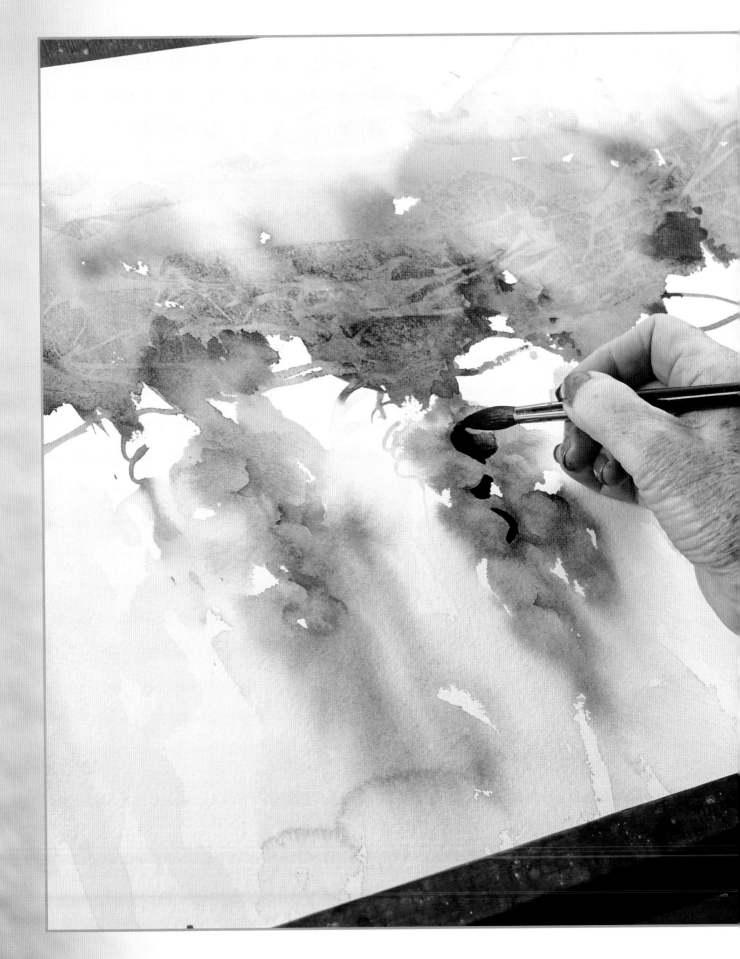

What we need

'For now, all you need are a few brushes, paper and colour.'

To be honest, very little is needed to get started with painting as a way to stay calm. We are not talking about painting for galleries, exhibitions or shows, so the materials we need are far less than the professional artist would aspire to own. For the exercises and paintings in this book you need only the bare minimum of equipment. However, if you find yourself enjoying painting, then by all means expand your materials as your passion for painting grows.

Keeping it simple

For now all you need are a few brushes, some paper and tubes of colour. An old plate could serve as a palette. Any container can be used for holding water. Once you have these you are set to go.

The essentials

Brushes, paper, a few tubes of colour, a plate for a palette and a jar to hold water. This is all you need.

Brushes

I suggest starting with just a few brushes. Please do not invest a lot of money in expensive brushes until you know whether painting works for you. Yes, if you want to, you can buy the best brushes you can afford. If you are just starting to paint, however, I recommend buying just two round brushes to start with – a size 10 and a larger size 12.

Be aware that there are many brands of brushes on the market – I have my own personalised brush range which is fantastic to use. Painting is my profession and they are a joy to work with.

TIP

An old toothbrush could come in very handy for spattering.

Watercolour paper

'The way we will be painting is to enjoy the creative process.'

The paper you choose is a different issue from brushes. While there are many cheap papers available, to be honest you are better off buying a good quality heavyweight paper specifically intended for painting in watercolour. You can buy packs of any watercolour paper at reasonable prices from art shops or online.

Take note that very cheap paper buckles once colour and water are applied, which ruins the sense of achievement and can seem soul-destroying. The way we will be painting is to enjoy the creative process, so it is vital to have the right materials to do so.

Please remember that you can paint on both sides of good paper. Never throw any scraps of watercolour paper away as they are useful for small exercises. In fact, don't part with any of your paper until it is covered with colour.

Pigments are often ground from natural stone to create glowing colours, ready made for us to use and enjoy.

Colour

'Use absolutely any colours that you wish to, because painting is personal.'

Colour is a fascinating area when painting and there are now a huge number of watercolour brands to choose from – so many that it can be quite daunting when looking at the selection available. One point that is vital: only buy products that actually have the words 'watercolour' on them. I prefer to work with tubes of colour rather than pans (hard blocks of dry watercolour). Again, this is a personal decision. The more frequently you paint, the more you will find what works best for you.

I am sincerely hoping that you will fall in love with colour and find it as soothing to work with as I do. To get started, three tubes of colour are all you really need – a red, a blue and a yellow – but you can add to your colour collection as your confidence and curiosity grow.

An old plate

You will hear artists talking about their palettes. This is the equipment in which they store their colour and work from. I have my own palette which I love, but over the years I have found painting from a simple white plate works just as well. An old plate or one from a charity shop will be absolutely fine.

Just pots

My water containers are any old pots I can lay my hands on at the time. I often use discarded containers from washing products. See-through water pots are best so that you can see if your water is clean or not, but literally anything that holds water is perfect!

Raiding the kitchen

The materials on the previous page give you everything you need to paint, but a few items from your kitchen, like salt and plastic food wrap add to the joy in working with watercolour. There is absolutely nothing that I do not paint or enjoy working with – almost anything you can lay your hands on, such as old lace, string or pieces of card, will help make patterns. In fact, I even paint with my coffee or tea on scraps of paper, creating whatever comes to mind from a blob or stain on paper – just like the face on the opposite page.

Once you learn to relax through creating, you will find yourself wondering how many ways you can come up with colour ideas on your own – from all manner of things, not just bought pigment. However, now it is time to stop talking about painting, and start actually doing it.

'It's time to paint yourself calm.'

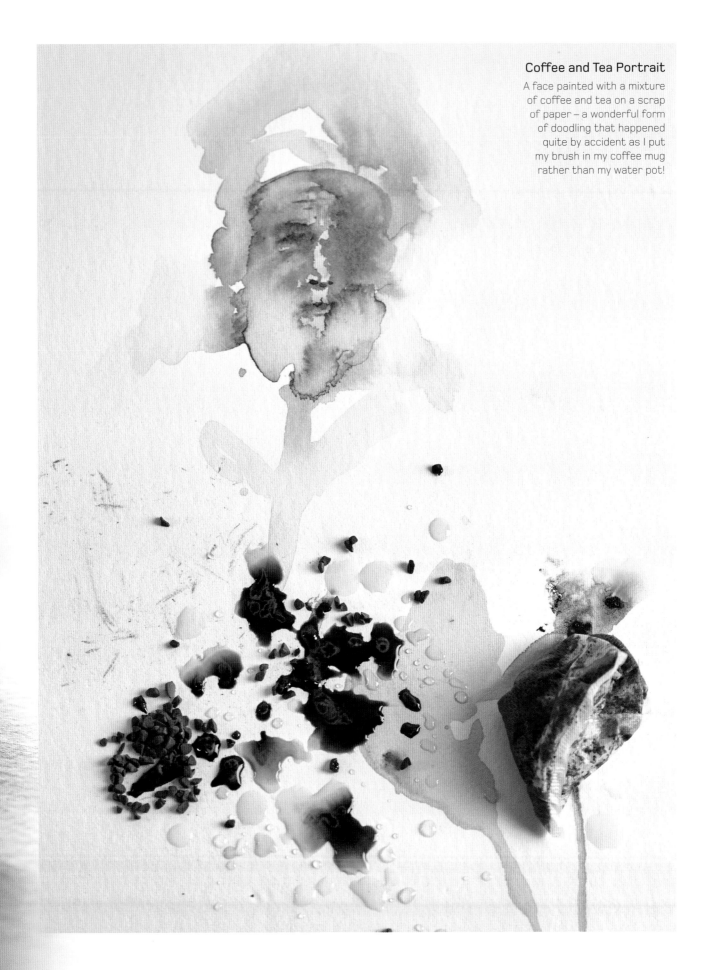

Coffee and Tea Portrait

A face painted with a mixture of coffee and tea on a scrap of paper – a wonderful form of doodling that happened quite by accident as I put my brush in my coffee mug rather than my water pot!

Colour flow

Colour brightens our lives. There is no doubt about that. What we are going to look at in this section is simple scenery and the process of painting as a form of escape. No matter what is happening in our lives, by working with colour, we can take control of how we feel.

I am not talking about painting masterpieces. That requires skill and, with the training involved to reach that point as an artist, can add pressure – which is exactly what I am aiming to avoid in this book. The simple art of applying colour to paper is enjoyable when there are no high expectations from the results.

You may have looked at art books in the past and been put off from painting, feeling you could never paint like the demonstrating artist or author. But everyone can paint – and why shouldn't they? Art isn't an exclusive club for those who are gifted or know what they are doing. You, the reader, can have an incredible life-changing experience simply from playing with colour.

First I am going to show you a few landscapes that anyone, believe it or not, can paint. We are looking at how to allow colour to flow across paper to form simple scenes – or not; because your results could be just as beautiful as abstracts.

'Art isn't an exclusive club for those who are gifted or know what they are doing.'

Imaginary Landscape

This semi-abstract landscape was created by letting the colours interact on paper. I call this 'accidental painting', because you are simply placing colour on paper and allowing it to 'play'. It will form patterns that may or may not work. Whatever the result, the pleasure here is in playing with the wet colour, not simply looking at the result. Of course, in this case, the result is, happily, quite pleasing.

Simple landscapes

I would like you to imagine you are surrounded by the most beautiful countryside. Maybe you have seen fields of golden corn or poppy fields with the delicate flowerheads blowing in the breeze. Whether you have or not is irrelevant, because we can see the scene in our minds by using our imagination.

By painting with beautiful glowing colours, we take ourselves to places we may never visit or return to; or to places that make us feel happy. They can be imaginary or real places – the choice is ours – but we can feel so good just by aiming to capture the beauty of nature in watercolour. I will describe what I mean using the three simple landscapes on the following pages.

You choose

By taking a sheet of white paper and making a decision where a horizon line could be, we can create a simple landscape. Colour placed above the horizon line can represent a sky, which does not have to be blue – it could be a red sky, or dark for a storm or dusk.

You choose.

The foreground can be any colour you wish to work with. Golds for cornfields, or red for poppies – or simply green for grass.

You choose.

Just hinting at trees in the middle ground between the sky and foreground can add interest – but they don't need to be there.

You choose.

Opposite:
Poppy Fields
28 x 38cm (11 x 15in)

Cornfields in Gold
The rich golden colour suggests cornfields. A very easy simple scene.

Three landscapes, three choices

The three example landscapes shown here are very easy to create in watercolour. More importantly they are relaxing. You can imagine you are walking past these fields as you create them.

To get started we need to know how to make colour flow across paper. So let's do that first. Imagine you are setting out on a journey. It is nice to know where you are heading, but you will need a map: instructions on how to get to your chosen destination. The next few pages are your map; your guide to how to get where you are heading when painting. The following exercises are intended to be relaxing, to help you enjoy painting in a way that makes you feel calm, happy and rested – not stressed!

Let's go. But before we do, remember that you are in control at every stage. You can stop or start painting whenever you wish – and you choose which colours you would like to use.

You choose. You are in control.

In the Distance

Using different shaped pieces of paper can make a
dramatic change when painting a simple landscape in
watercolour. This scene is painted in the same way as
Cornfields in Gold but at the front of the landscape
I have added just one plant, a simple and effective
change which alters the character of the piece.

Poppy Fields

This watercolour is a little more complicated as I am aiming at
giving the impression of poppies in the foreground but, to be
honest, anyone can paint this scene. Truly! Its use of water flowing
through colour creates beautiful patterns.

Simple colour flow exercises

'What could be more important than relaxing or giving yourself some real quality time to unwind?'

Often, when we plan something we want to do for ourselves, we try to do it too quickly so we can fit it in to our already busy day. Maybe we leave it until the end of the day, when we are too tired to thoroughly enjoy it; or at the beginning of the day, when we have other things that we wish to achieve. I am going to offer advice to help.

Make time to relax!

If you are racing through the exercises on these pages, you will not get the most out of them. The experience of painting should be enjoyable, so set yourself some quality 'me time' to paint. Make this time all about you and you alone. I know this can be hard, because we always seem to find time for everyone else or other 'more important' things to do than relaxing. But when you think about it, what can be more important than relaxing or giving yourself real quality time to unwind. You deserve it – don't you?

So now you have chosen the time to paint and set the atmosphere for learning, relaxing and getting to a calm state when painting.

Preparing to paint

First, let's look at how to load your brushes with colour and also consider how to clean them in between changing colour and when you have finished painting.

What you need:

- Scraps of clean white paper
- A tube each of yellow and green watercolour shades
- A brush and clean water

How to load colour and clean your brush

If you have never painted before, this is how you will be picking up colour. At the end of each painting session it is a wise precaution to clean your brushes by rinsing them in clean water.

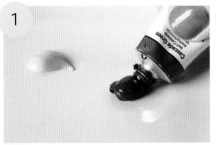

1 Squeeze a small amount of colour onto a white plate or, if you have one, a palette.

2 Load water onto your brush by dipping it into clean water.

3 Now put your brush onto the pigment. The pigment will load onto your wet brush readily, and you will be ready to apply it to the paper.

4 You will need to clean your brush each time you use a different colour. This is easily done by placing your brush in your water pot and gently swirling it.

5 To remove excess water at any time when painting, gently glide your brush over the side of your water container.

6 At the end of every painting session clean your brush, then use your fingers to smooth the brush into its original shape. If you look after your brushes they will last you a long time.

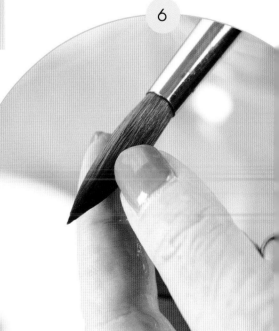

TIP

Never leave brushes standing in water, as this can ruin them – especially if you are using better quality sable brushes.

What you need:

- A scrap of clean white watercolour paper
- Yellow watercolour paint
- A brush and clean water

Let's paint

Take three scraps of paper and try these three simple exercises. In the first, below, I am asking you simply to cover a whole sheet of paper with yellow pigment.

Exercise 1: Colour flow

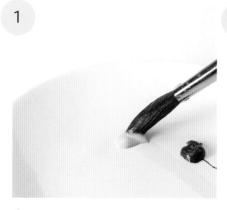

1 Squeeze a small amount of colour onto a white plate (or palette if you have one). Load water onto your brush by dipping it into clean water and then put your brush onto the pigment to load the brush, as explained earlier.

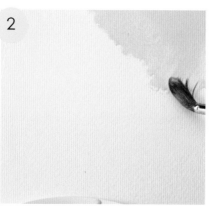

2 Place your brush onto the paper and move the colour across it from top to bottom. You can start at the top and move downwards by adding colour in sideways brushstrokes, or you can move your brush diagonally.

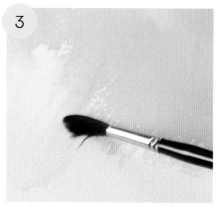

3 Put your brush in clean water and place a line of water next to the pigment on your paper; you will find the colour from your previous brushstrokes runs into the wet space. The colour here will be paler as freshly applied water will dilute the pigment placed previously.

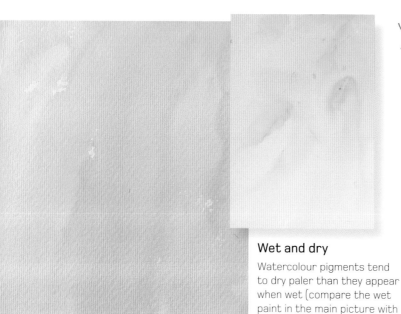

You are in control

When painting this exercise I held my paper at an angle so the colour ran from the top of the page to the lower corner. This is called 'colour flow'. You can paint with your paper flat or at an angle. If you move the paper once you have added colour you can encourage it to run in any direction that you wish.

Wet and dry

Watercolour pigments tend to dry paler than they appear when wet (compare the wet paint in the main picture with the dry inset) so you need to go in with quite strong colour initially to allow for this unless you want a very pale result.

Exercise 2: Colour control

You may have heard that watercolour is the most difficult medium of all to work in, but it is the most magical. Each time you paint with exactly the same pigments you gain different results – each unique and fascinating.

They say you don't have control with watercolour. But you do – just look at this exercise.

What you need:

- The same items as you used for the colour flow exercise opposite – plus a fresh sheet of clean white watercolour paper

1

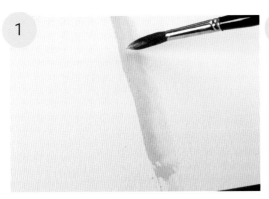

1 Take a clean piece of paper. Load your brush with the same yellow colour and draw a line down the centre of the white paper.

2

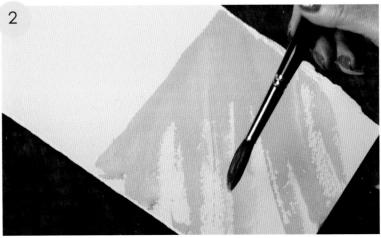

2 Next, paint just one side of the paper. Paint in lines or diagonal brushstrokes. Leave some of the paper white if you wish, or cover it all. Even if your paper is at an angle, the colour will not move onto the dry area. It will only go where you want it to. You have control.

3

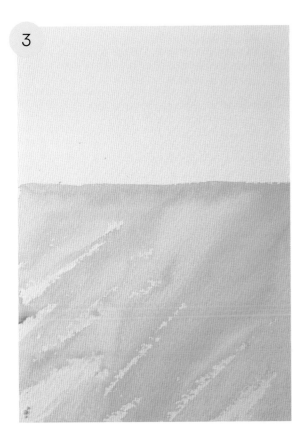

3 When the colour is completely dry, turn your paper sideways and see what you have painted. The early beginning of a very simple landscape. You are now painting! Great, isn't it? – and so easy. Later on, you could add a blue sky above the horizon line, if you wish.

41

What you need:

- A third scrap of clean, white watercolour paper
- Yellow and green watercolour paints
- A brush and clean water

Exercise 3: Two colours

This is the third of the three simple exercises. In the last exercise you painted a yellow line on dry paper. Now you are going to draw a line on still damp paper with a new colour – green.

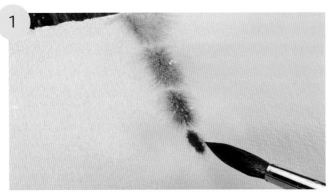

1

1 Start by painting a whole piece of paper yellow (as in the first exercise) and let it dry slightly. Look to see when the sheen starts dulling, so you know that the paper is still slightly wet. While your yellow paper is drying, clean your brush in the water ready for the next stage. Load it with a green colour. Now for the fun part. Use your brush to paint a green line in the centre of the paper, whilst the yellow pigment is still damp. Do not fiddle or try to paint anything. Just apply a line of green colour and watch it play and interact with the still-wet yellow pigment.

2

2 The green pigment should merge with the still damp yellow colour and spread. This interaction is fun to watch. You can make the centre line stronger in colour if you wish by repeating this process with a second line on top of the first, while it is still wet.

TIP

Do not use a hairdryer to speed up this action. Left to dry naturally, the results will be far more interesting!

3

3 Now turn your paper sideways as in the previous exercise. Look – you have painted the beginning of a soft landscape, with trees in the distance. Not bad, is it?

Pigment interaction

Again, this is very simple. Believe me, the fun gets better the more you paint and the more you allow yourself to enjoy painting. You can paint. You really can – you can be brilliant if you wish to be!

Sunshine on your shoulders

Repeat these exercises, but this time try imagining the sun on your shoulders each time you work with the yellow shade.

If it helps, before you start painting, close your eyes and try to imagine the sun kissing your skin. Imagine being on holiday relaxing. Imagine trying to look at the sun and having to close your eyes when doing so.

Imagine it is a beautiful day

Now, in this mood repeat the exercises and enjoy them. Don't race them and please learn from each one. Watch what the pigment does if you add more or less water or if you change the direction of your brushstrokes. Watch what happens if you add a green line when the yellow pigment is still very wet!

What next?

How else can we enjoy colour
flowing? Let's see!

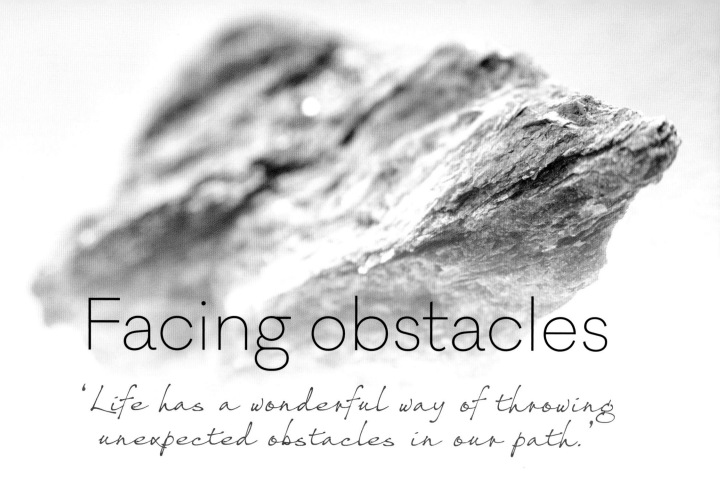

Facing obstacles

'Life has a wonderful way of throwing unexpected obstacles in our path.'

In the previous chapter we discussed making quality time to paint. However, finding time to do anything we enjoy is not always easy. Hobbies or activities that are solely for our own pleasure often find themselves at the bottom of the 'to do' list. As families, work and other matters become higher on our list of priorities; we become unimportant in our own daily routine. I know – this has happened to me in the past. You plan ahead to do exactly what you want to do, but something more urgent gets in the way – and so you postpone your free time. 'There is always tomorrow.' However, that tomorrow when you have time to yourself never seems to arrive.

It was only when I made a conscious decision to treat painting like eating, as part of my daily routine, that my life and art career changed. More importantly the happy calm state I am in when painting helps me deal with other issues far more easily. During and after my painting time I am more aware and able to think calmly about how to prioritise and plan other aspects of my life – and this is why I can achieve so much.

By making time to do what I enjoy, I find more time to be extremely effective in the daily lists of things that I have to do – and I am then in a much better frame of mind because of my relaxing a little each day via painting. People who make time to relax seem to enjoy life far more. I do, and I want you to as well. However, even when we do finally manage to plan ahead and make time to do what we enjoy most, life has a wonderful way of throwing unexpected obstacles in our path.

Obstacles

What kind of obstacles can stop us painting? Lack of confidence or belief in our ability. Illness. Emotional upsets. Stressful careers. Unstable relationships. Depression. Anxiety.

Painting can help each of these situations. It is a form of escape to somewhere peaceful. I will look into this later in my book but for now I want you to imagine you are facing obstacles – of any kind, no matter how large or small – and use that feeling in the exercises in this chapter.

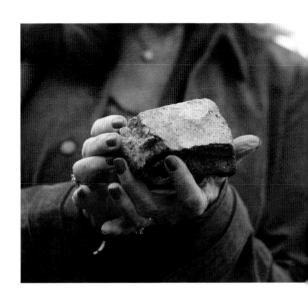

Boulders on our shoulders

'Every problem we carry is like a boulder on our shoulders. A heavy weight.'

I find it interesting that many watercolour pigments are created out of rocks. For example, beautiful gemstones like amethyst are used to create glowing purple shades. I visited the head office of the paint manufacturer Daniel Smith in Seattle USA and was given a fascinating tour of how their watercolour products were made. I was in awe of the natural pigments being broken up into fine dust to make the gorgeously vibrant colours that I paint with.

In a way, you are moving the biggest of rocks when you are painting. If these giant stones can be moved by your hands, you are already achieving something wonderful in overcoming obstacles which, of course, come in all sizes too.

The natural pigments of gemstones are used to create glowing watercolour shades to paint with. Here you can see fuchsite, azurite and lapis lazuli, along with paints made from those minerals.

Colour and personality

Each tube of colour that you purchase has already been prepared for you by the manufacturer, so all you have to do is choose your favourite colours to paint with.

Colour choice can be an extension of our personality as well as our mood. Some artists opt for shades that make them feel happier or content when painting. People who buy paintings often choose pieces that give them an emotional effect when they look at them, not simply because they like the subject or scene. Colour really carries a huge impact.

Even the most seasoned artist will have a block from time to time where they feel unhappy painting. That would be their obstacle to overcome. However, as we are not looking to paint subjects yet – only colour and how to use it – our obstacle to overcome at this stage is time. So please make some time at least once a week to paint. Watercolour, and how it reacts with water, is so addictive that you will find yourself wanting to paint every day soon as your confidence grows.

I think that when we first start painting, everything is so confusing. What to use, where to start, and the 'Can I do it?' feeling. I will face each of these obstacles throughout the following pages. When colours run together and form a beautiful pattern, everything else can be forgotten. The confusion disappears gradually as the fun begins.

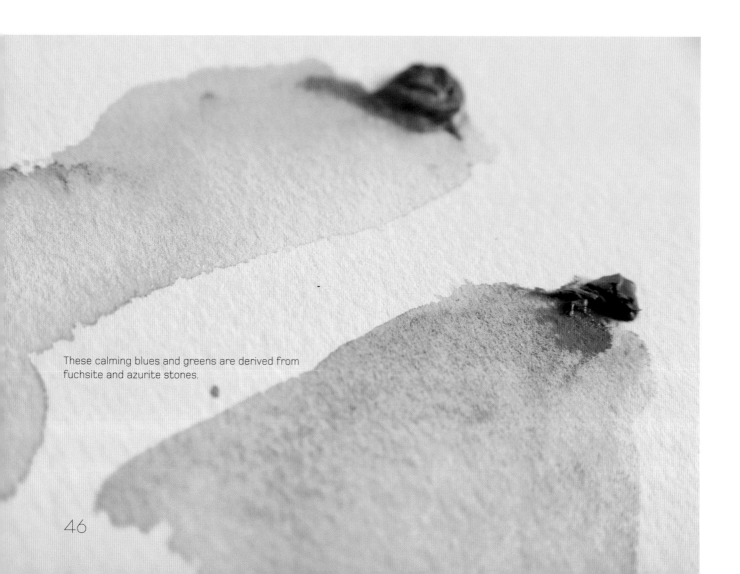

These calming blues and greens are derived from fuchsite and azurite stones.

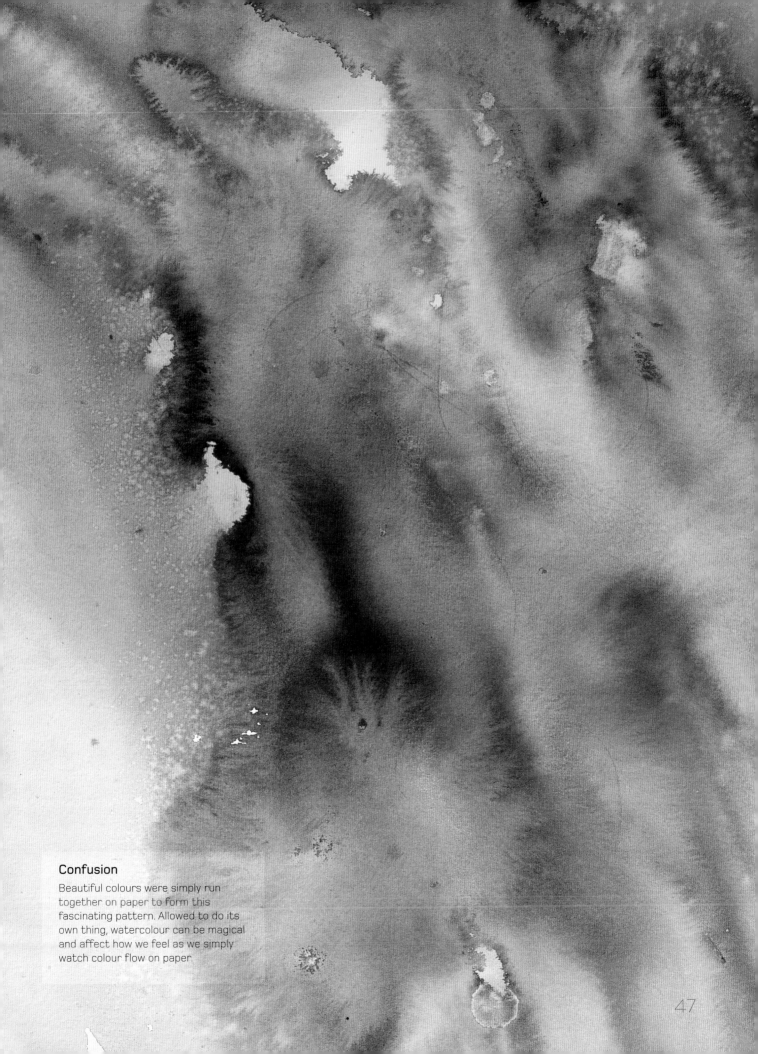

Confusion

Beautiful colours were simply run
together on paper to form this
fascinating pattern. Allowed to do its
own thing, watercolour can be magical
and affect how we feel as we simply
watch colour flow on paper.

What you need:

- A scrap of clean, white watercolour paper
- A number of blue watercolour paints – or just one, depending on how you feel
- A brush and clean water

Exercise: Waterfall

Running water freely through pigment and allowing it to dry naturally will form stripes in the colour. This result is quite beautiful and easy to achieve. I see this as representing life when there are no obstacles in the way.

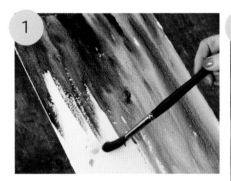

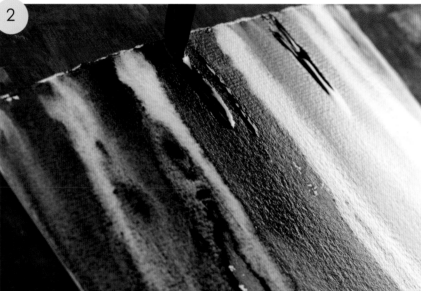

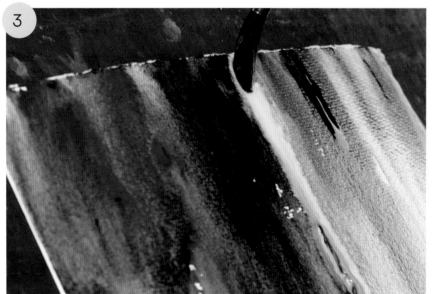

1 Take a scrap of paper and place colour all over it using the paints you have selected.

2 Put your paper at an angle and use a clean damp brush to apply water to the top of the paper while the colour remains wet.

3 Allow it to run in lines through the still damp pigment.

Opposite:
Waterfall
You should end up with an effect like this, achieved by water running through pigment on paper. The more beautiful the colours you select to paint with, the more enjoyable your painting time will be. Choose whatever you feel like using; yellow, red, blue or green. In fact, try the exercise repeatedly using different colours each time to see what happens.

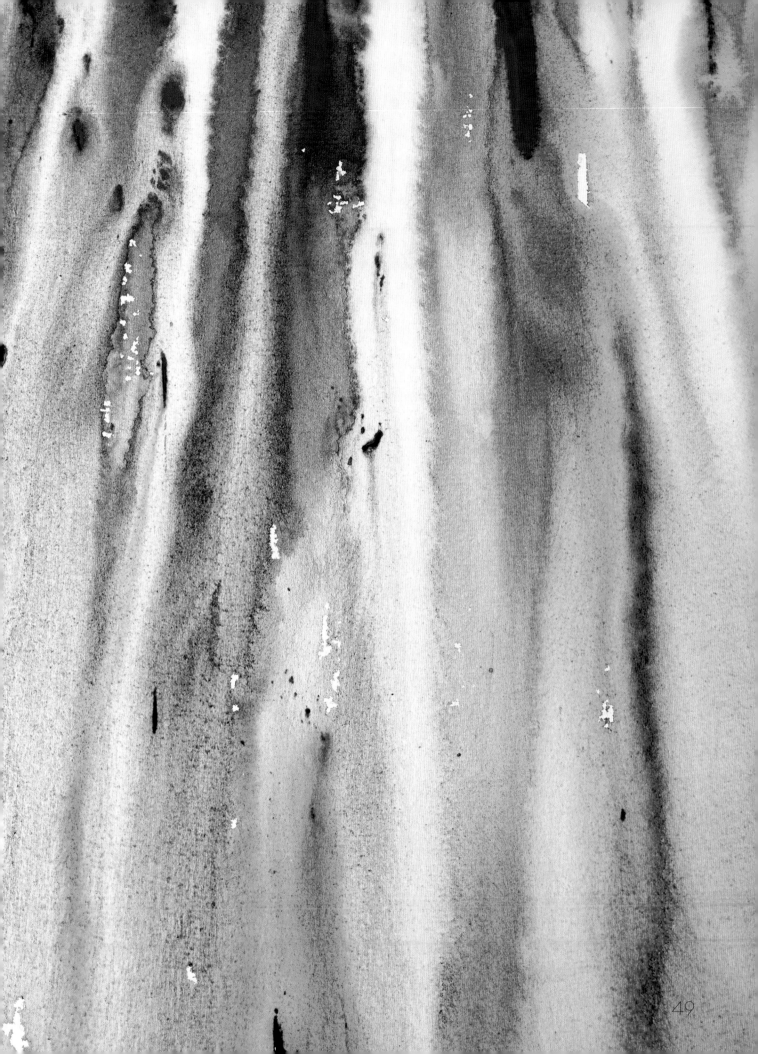

49

Exercise: Creating obstacles

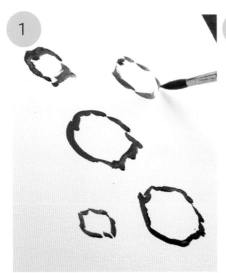

What you need:

- A scrap of clean, white watercolour paper
- Two blue shades – or just one
- A brush and clean water

We can not control the obstacles that occur in our lives, but we have complete power over where to place them and how to overcome them in watercolour. The waterfall experiment was simple, because there were no obstacles preventing the colour from moving at will. Now we are going to add some – or I should say, you are, because you are in control here. I am just guiding you.

The materials you need are the same as earlier: scraps of paper and a few watercolour shades. One or two as you wish – you choose.

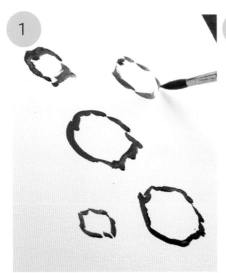

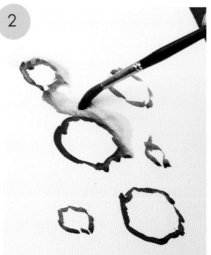

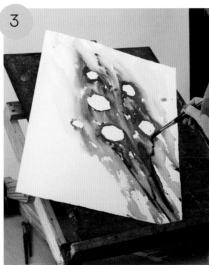

1 Taking a scrap of paper, paint the outline of five 'obstacles'. They can be round, square, large or small – whatever size of shape you wish them to be. You will need to act quickly for this exercise as you cannot allow these outlines to dry before you run colour around them in the following stages.

2 Soften the outline of each obstacle with your damp brush to allow the colour from the initial painted outlines to run into the newly wet area beside each obstacle.

3 Keep adding fresh colour to the areas around the obstacles and even hold your paper at an angle to watch the colour run around the dry shapes left on the paper. Watercolour pigment will only run where it has been invited into wet sections. Your outlines have prevented colour running into the dry space, so your obstacles will remain dry. In a way you are protecting these spaces. In fact instead of being obstacles these are now the safe zones – places to feel secure from each colour application. So we have accidently turned negative obstacles into positive space. I find looking for the positive in every area of life is always a neat trick and we have just done that!

4 As you paint, you can introduce more obstacles in the space surrounding the initial ones. Add different sized obstacles and allow colour to flow around them merging with still-wet colour already around the existing white shapes on paper.

Obstacles or opportunities?

That was simple, wasn't it? Very easy to do. Painting should always be that easy when you are painting for fun or to de-stress.

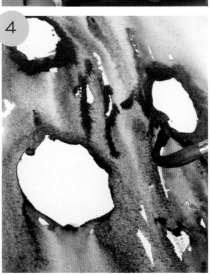

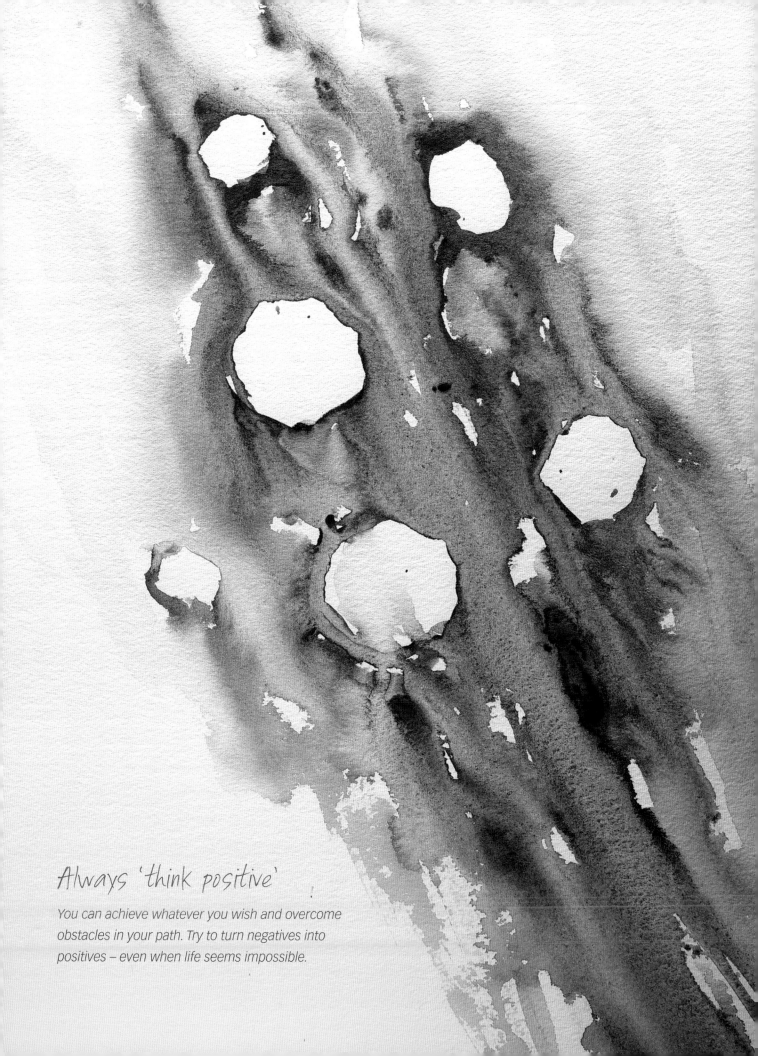

Always 'think positive'

You can achieve whatever you wish and overcome obstacles in your path. Try to turn negatives into positives – even when life seems impossible.

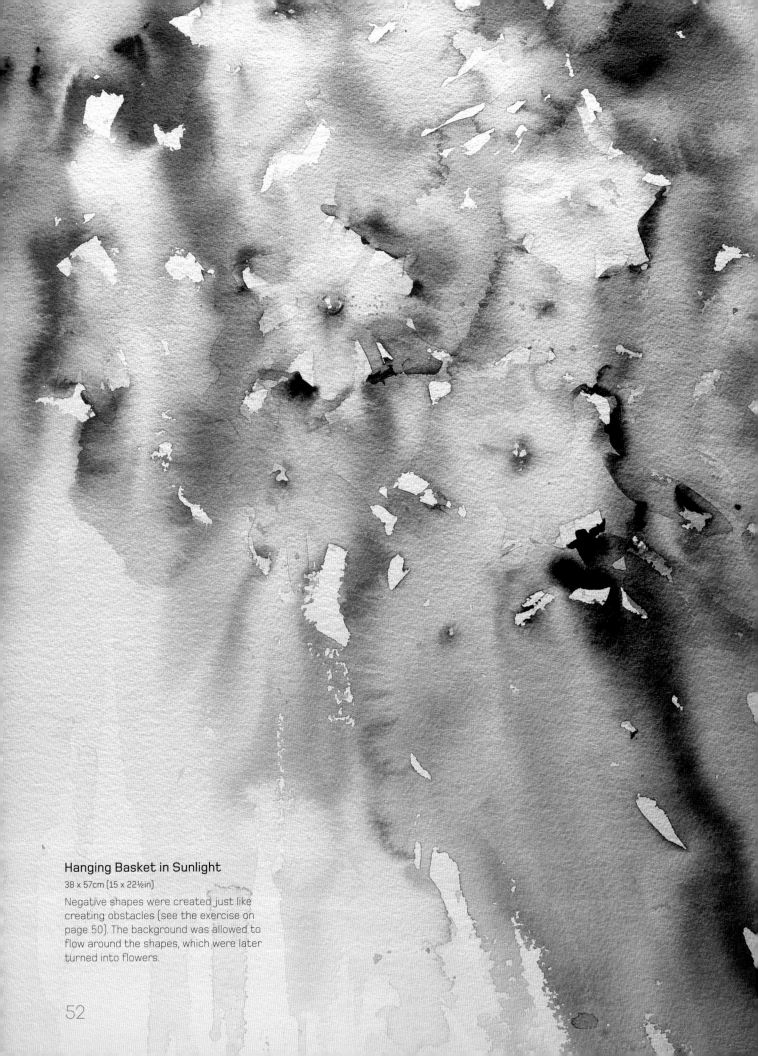

Hanging Basket in Sunlight

38 x 57cm (15 x 22½in)

Negative shapes were created just like
creating obstacles (see the exercise on
page 50). The background was allowed to
flow around the shapes, which were later
turned into flowers.

Negative painting

Running colour around 'obstacles' to make patterns is referred to as negative painting. This is a form of painting where you paint the background first. You could use the shape of something you really like as your initial outline – a boat, perhaps, or an animal or flower. You can then paint the subject itself later on, if you wish.

For now, you may be painting to calm yourself, but these techniques and painting skills will help you become an artist – or a better artist – if you continue with them, as they will improve your painting skills. They can lead to paintings like those on these pages.

Not every painting needs to be in strong colour,. Sometimes painting in soft muted tones can be far more relaxing. In the little carnation study I simply allowed soft colour to flow around circular shapes which I filled in with colour to create the flowers.

For now, I really want the focus to be on enjoying placing simple colour on paper in a variety of ways to create different effects. Think about how doing so can change our mood, lift our spirits and help us to relax. So what next?

Turn the page!

Simple Carnation Study
14 x 39cm (5½ x 15¼in)

Nature's calming influence

'Working with peaceful colours and restful thoughts can help us reach a relaxing state of mind.'

There have been times in my life when seeking a few minutes of peace and quiet has seemed almost impossible. Life has thrown an obstacle in my path which has not always been easy to overcome. It is at times like this in life that escaping via painting has helped me so much. Working in watercolour makes facing and overcoming obstacles far easier, as seen in the previous chapter.

When needed, I have closed my eyes, imagining I am walking through the countryside. I like the thought of newly mown grass and walking over it barefoot, taking in that fresh scent. I also love the idea of walking through an imaginary field of tall grass, touching it with my hands and feeling it move. In my mind, I can lay on a lawn looking up at a clear blue sky at any time. In my imagination, there is always a perfectly blue cloudless sky. I suppose in my imagination life is perfect. I can fall into my world of painting to take me to a calm place whenever and wherever I want to – and it's free. You can too.

I am lucky in that I live in the countryside, surrounded by rural lanes with fields that are stunning throughout the year as the seasons change. I was brought up in Wales and knew only too well the luxury of seeing green around me on almost every journey. When I moved to Hong Kong and then Dubai, I missed home – I sound like the singer, Tom Jones, missing the 'green, green, grass of home'! But I did – and I managed to escape to it through my painting. I hope to help you escape via painting too, whatever you are going through or whatever you are feeling. By helping you feel a sense of peace, painting can change your mood and in turn your life.

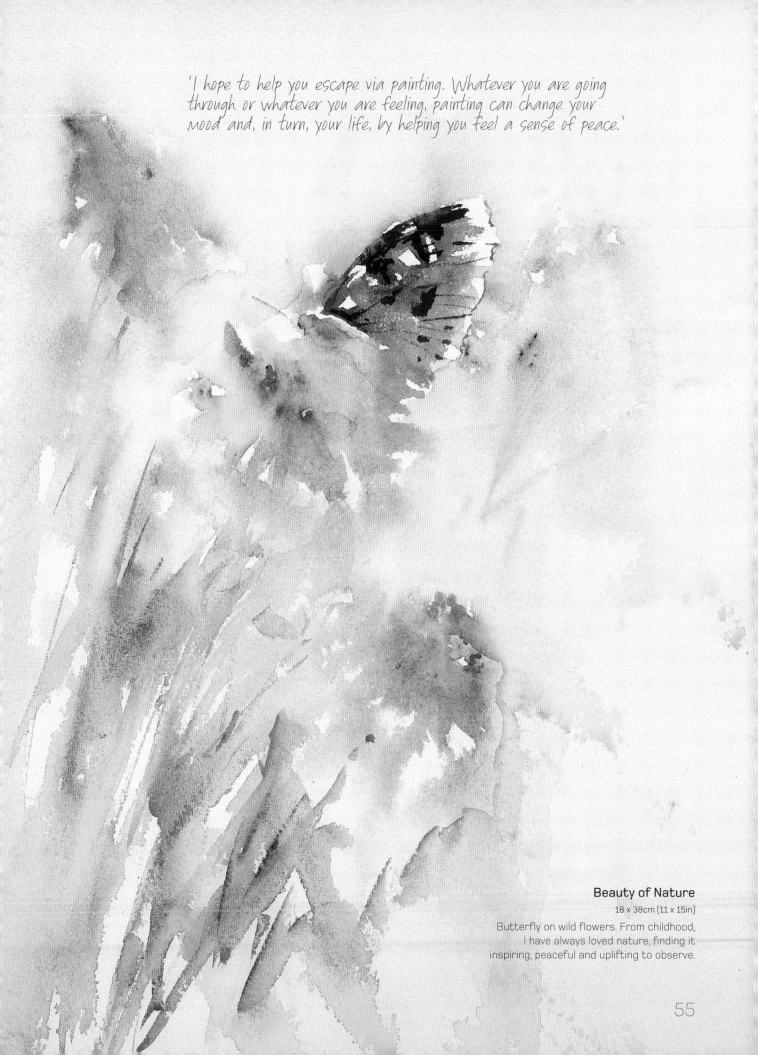

'I hope to help you escape via painting. Whatever you are going through or whatever you are feeling, painting can change your mood and, in turn, your life, by helping you feel a sense of peace.'

Beauty of Nature

18 x 38cm (11 x 15in)

Butterfly on wild flowers. From childhood, I have always loved nature, finding it inspiring, peaceful and uplifting to observe.

What you need:

- Green and yellow watercolour shades – I have used two green shades and one yellow
- A brush and clean water
- Scraps of watercolour paper
- Plastic food wrap

Exercise: Visual refreshment

The colour green symbolises nature. It is visually soothing and enables us to feel refreshed when we are surrounded by it. It is a constant reminder of spring, when new growth appears, which is why it is often used as a colour to represent energy and new life.

If you are tired or feeling low, green is said to bring you a sense of wellbeing. This makes it a wonderful colour to work with. Choosing a calming colour and subject that aids visual relaxation is a superb combination for lifting your spirits.

For this exercise, take one or two shades of green, depending on what you own. Keep a yellow shade at hand to add a feeling of sunshine to your work.

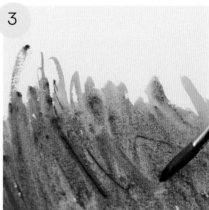

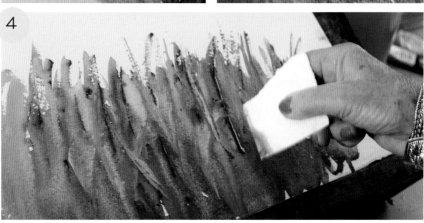

1 Squeeze some of each colour on one side of your paper.

2 Wet your brush and create pleasing effects by touching the green paint with your wet brush and drawing the pigment across the paper.

3 When you have green covering the lower half of the paper, use your brush to pull lines downwards and upwards onto the white part of the paper at the top. Next, begin to use the yellow pigment in the same way, allowing the two colours to merge. Let your brushstrokes represent blades of grass. Think about the subject as you paint – the goal is to create an abstract feeling of grasses.

4 While the colour is still wet, you can use pieces of watercolour paper or card with a straight edge to create lines and patterns to represent blades of grass. Simply place the card on the still-wet pigment and slide it up and down. Lifting it will remove a little of the pigment and leave interesting patterns. Visualise touching grass as you paint this scene.

TIP

In this exercise, the pigment is squeezed directly onto the paper to work from rather than using a palette. The needs of an artist can be simple and vary from project to project. That is what makes painting so much fun.

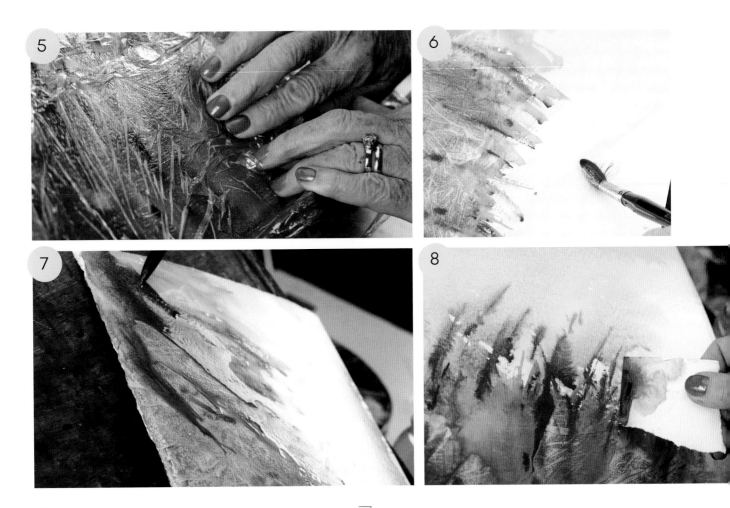

5 Lie a piece of plastic food wrap directly over the top of the wet paint, and push it with your fingers – you will be able to see the patterns you are making through the clear plastic. Pushing the film together in tiny pleats will give you straight or curved line patterns. Creating texture in your work in this way can be great fun.

6 When your paper is dry, remove the plastic food wrap to enjoy the pattern you have created. Start painting again by applying a layer of yellow colour over the top white paper. The yellow will represent sunshine hitting the grass on a summer's day – a wonderful feeling.

7 Turn your paper at an angle on the board. You can now apply some more colour, placing darker green on top of the first application. Allowing the new paint to run softly into the still-wet yellow area above will give beautiful results.

8 You can use pieces of paper or card to apply the colour in place of a paintbrush if you wish. Picking up colour with the side of a piece of paper and placing it in lines on the still-wet areas will create more beautiful grass effects. Really lovely patterns can be created this way for all manner of subjects. This is so simple to do and so enjoyable and relaxing.

Rest

Take your time and enjoy watching the colours interact. There is no race in this exercise, just the pleasure of seeing colour come to life and make beautiful patterns as it does. You can leave this painting exercise at this stage, or you can work further by adding to the upper yellow section.

As you can see on the following pages, I chose to add dandelions. Though they are classed as weeds, I find them really beautiful to paint.

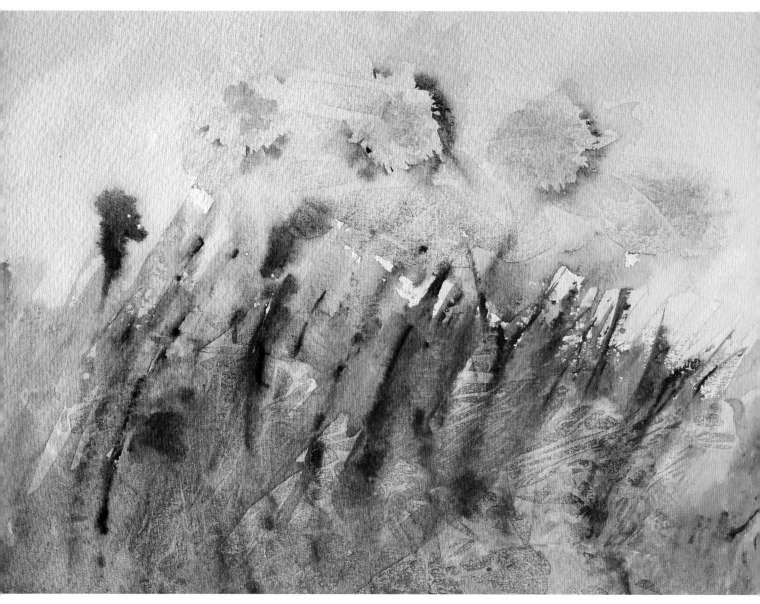

Visual Refreshment

Simple dandelion flowers have been created on the yellow top area of the demonstration (see opposite for how this was done). I never waste any paper or experiments. I find subjects to paint on top of them, still experimenting.

Now you can try the visual refreshment exercise again, but trying something new and different. How about painting a blue section above the green to represent a blue sky? You could use larger or smaller pieces of watercolour paper so that the length of your brushstrokes for grass can be longer, taller, thinner or thicker throughout the piece.

All of the small exercises here and on the previous pages are leading you into a wonderful world of art, where you can paint more serious subjects in future and more complex scenes if you want to. But remember, you can choose to paint only pleasing, calming, simple subjects, which is relaxing and it is meant to be.

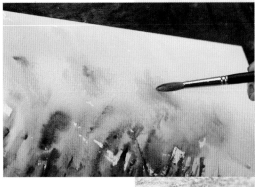

Adding the flower centres.

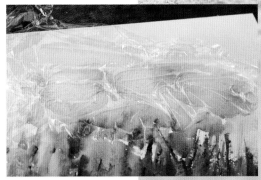

Plastic food wrap is shaped to form petals around the wet paint.

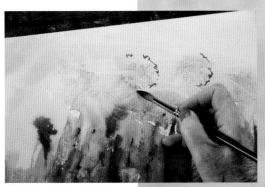

Touches of green paint are added around the flower centres.

Adding the dandelions

I began by placing deeper-coloured centres, using orange paint. I then simply repeated the plastic food wrap technique by covering the upper freshly painted yellow section with food wrap. But this time I squashed and crinkled the film to make tiny patterns to form flower petals. I left the colour to dry at this stage.

Once the colour was dry and I had removed the food wrap I formed a circular outline for flower shapes where I felt they would look interesting. But you can add flowers, or not, anywhere you wish on your painting. Be careful to gently blend the outline colours into the background so that they don't dry as hard outlines. You can do this by adding water or more colour to the surrounding section.

And now I have impressions of dandelions in grasses. And I enjoyed this so much I can repeat the exercise and gain different results each time, because that is the magic of watercolour. You often never get the same results twice, which adds to the enjoyment of using it.

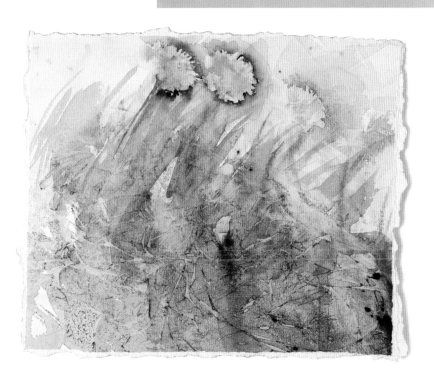

Simple Dandelions

Leaves, or beautiful flowers? Everything carries its own beauty.

Calming thoughts

You can use all of your senses while painting. When painting with green, try to imagine you are walking barefoot through freshly mown grass. Imagine the fragrant scent, the feeling of the grass beneath your bare feet and the sunshine on your shoulders. Imagine walking through a field, looking ahead to a clear blue sky. When you go to sleep at night take that feeling with you.

Painting can be a very powerful tool to the imagination, and not just when you are actually moving your paintbrush. But long after you have put it down too. Imagine painting long or short blades of grass as you drift off to sleep. But never imagine having to cut it or that thought will bring you quickly down to earth with a bump. We are avoiding all negative thoughts and only working on positive, calming ideas. So try to keep your focus on everything that is wonderful, and nothing that causes you stress or anxiety.

Each time you paint one of the exercises in this part of the book, improve your imagination by visualising green fields or beautiful lawns that stretch for miles ahead of you – and as you fall asleep imagine seeing that restful green. Our imaginations are so powerful that, when painting, we can transport ourselves to peaceful moments far away from any stress or problems that occur in life.

Imaginary Friend
56 x 38cm (22 x 15in)
Keeping our imagination alive as adults is not always easy, but when we paint we open the door to the opportunity to do just that.

Using your senses

How wonderful to be able to take the simple childhood pleasure of creating – with no pressure to achieve – into our adult years. Painting for enjoyment is all about just that: enjoyment, not stress.

Walking on grass, touching it or smelling it in our minds is a wonderful way to relax and unwind. And by simply applying green colour and allowing it to flow gently across paper we are gaining that feeling without even having to leave our home.

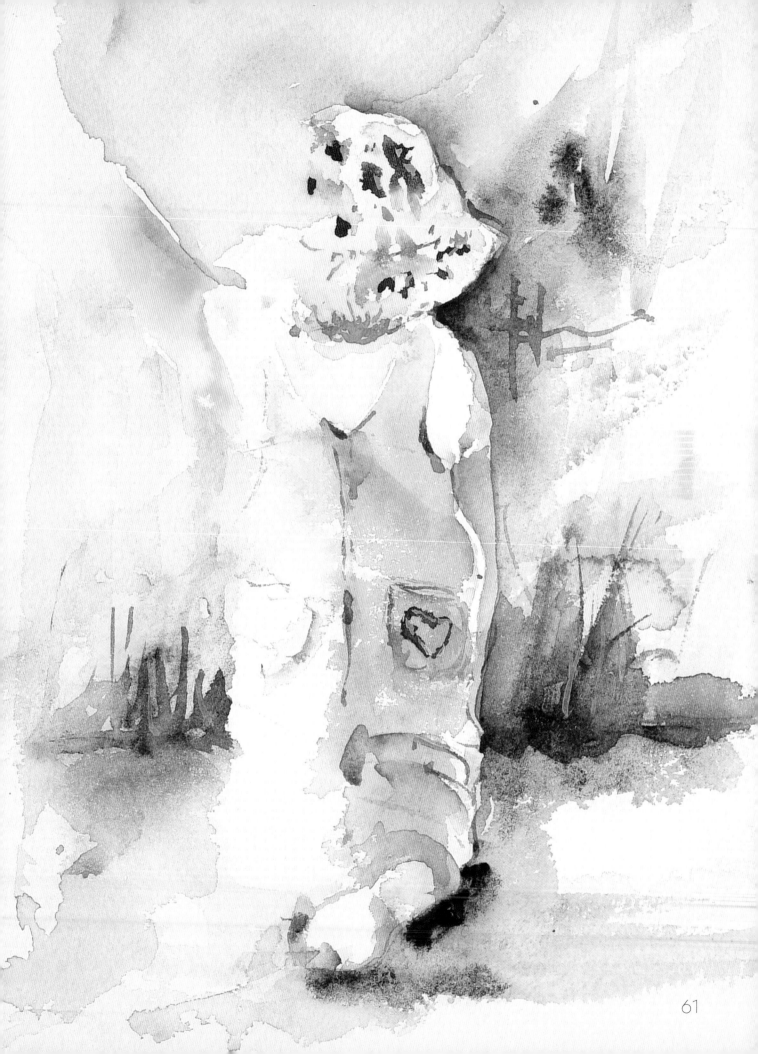

Exercise: Easy painting

Now it is time to paint again using green as the main colour. I am keeping this piece very simple so that I enjoy painting rather than worrying about detail or the result.

The joy, as mentioned previously, has to be in painting. Not the outcome, but the journey in creating itself.

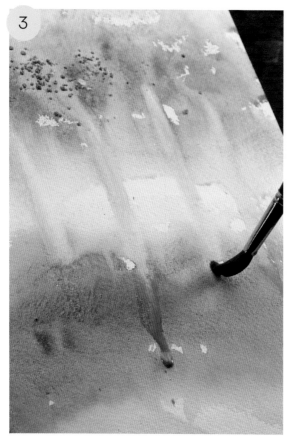

1 Place two lines of green and yellow colour across a clean piece of watercolour paper, one band near the bottom of the paper, the other band nearer the top. Drop water into these colour bands randomly and allow it to push the pigment out of the way. This will create fascinating patterns as it dries naturally. Keep the edges of these colour bands softened by using a sweeping brushstroke with water at either side of each.

2 While the paper is still wet, take an old toothbrush and use it to pick up colour. Next, hold the brush at an angle to your paper, and draw your finger and thumb over the bristles to flick the picked-up colour from the toothbrush. This is called spattering. This is a fun thing to do as the spattered colour will merge once it falls on the already-wet sections, creating patterns that could be leaves on the trees. You can also create interesting effects by dropping salt into the still-wet colour sections. This is another fun way to create texture when working in watercolour.

3 After spattering and applying a little salt for fun to the upper band of colour I have begun to hint at tree trunks by softly painting a few lines to connect the tree foliage at the top of the page to the green section below.

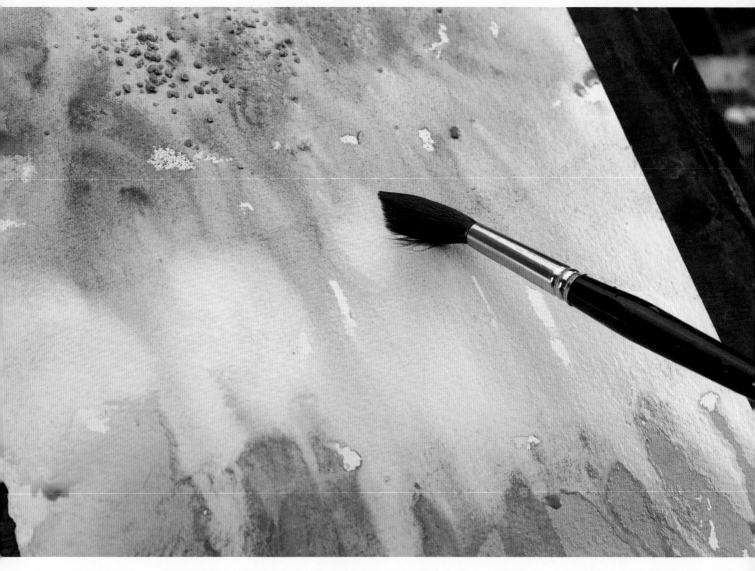

This atmospheric scene, where colour and water have interacted to create patterns, can be interpreted as a landscape or seen simply as beautiful colour fusions. Such scenes are incredibly relaxing to paint, especially as there is no goal other than to enjoy the creative process.

Making time to paint each day really can help to remove stress and anxiety. Stay relaxed once you have put your brushes down and look forward to your next painting session.

Paint these scenes often and imagine how wonderful it would be to walk through the woods while you are creating. Enjoy each brushstroke and each addition of colour.

When you are rested, put your brushes down and move on to the next section.

64

The peaceful zone

Imagine a peaceful setting, and peace in your heart, in your mind and soul.

It is a haven, to which you can escape whenever you wish – simply by painting and using flowing colour.

This section is for quiet painting time. A place to relax, unwind and enjoy colour.

'Alone. In peace.'

What is the peaceful zone?

'The process of painting in a certain way with the sole intent of using colour to calm ourselves can be a powerful discovery.'

Artists who paint professionally understand that there are times during painting when the whole world around them seems to disappear. It is possible to become one with what is happening during a creative process to such a point that nothing else exists – no problems, no stress; just a peaceful zone that aids switching off the mind to anything else that is happening. A connection forms which is almost indescribable. It is a feeling of inner peace. When I am in this calm, peaceful zone I almost feel as though I am living on a different planet, one where only beauty and harmony exist. This state of being keeps me feeling young, healthy and so very much alive. I feel rested after I have entered this zone. We can easily underestimate the power of colour and how using it when painting can affect us.

At times, painting is like reaching the highest of highs, as a feeling of euphoric happiness can overwhelm you. The peaceful zone is a calm state that is difficult for some to reach, because for many people, relaxing is not easy. I am someone who enjoys being on the go all the time and yet painting can calm me down and make me rest. Not only my body, but my soul at the same time. I believe painting can easily be compared to meditation. We can become our own mentors by learning which colours calm us the most and which flowing brushwork techniques we prefer to change our mood or how we feel.

The process of painting with the sole intent of using colour to calm ourselves can be a powerful discovery. However, we need to set a few goals before we begin painting, so that reaching them becomes possible and the journey into doing so remains calming and enjoyable. Before we move on, let's look at the value of simplicity.

The value of simplicity

In life it is far too easy to overcomplicate things, and in painting there is a huge possibility of doing exactly the same thing. Imagine packing a suitcase to go on holiday. The case will only hold so much. Before we start packing we have to decide what we really need and what we do not. The same is true of painting.

When painting we need materials – but they can be few, as discussed earlier in the book. We need time to paint; good quality time, without interruptions. We all deserve this, even if it is for only a few minutes every day or an hour a week.

This time is important and should not be something to race just for the sake of saying 'I painted today'. We need space: an area to create in that is quiet and set up with the purpose of allowing the quality time taken to be peaceful and relaxing.

Simple rules

Learning to simplify is such a valuable lesson. I love the saying that we were given two ears and one mouth for a reason. Learn to listen to sounds around you, and learn to see. Observe beauty and try to aim to achieve this in your painting time. It can be something simple like soft flowing colour or even simple subjects, but do not try to do too much in one session. Set the goal of painting only to relax during your painting time. Choose colours, simple techniques and subjects – if you choose them at all – that you enjoy.

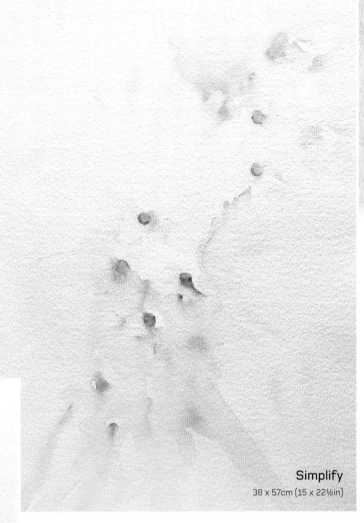

Simplify
38 x 57cm (15 x 22½in)

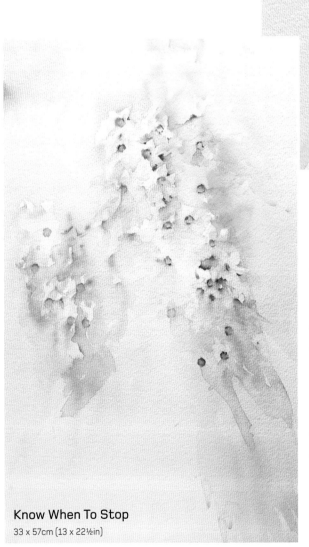

Know When To Stop
33 x 57cm (13 x 22½in)

No matter what is happening on your paper during the creative process, know when to stop. Stop when you are feeling good. Stop on a high. Even when a painting or exercise is looking fabulous, put your brush down at a moment when you feel really happy about what you are achieving and carry that feeling with you until you pick up your brushes again. Next time you paint, remember how great you felt and start painting with the aim of feeling exactly the same way. The creative process explained over the next few pages is about how you feel when you paint. It is not about what you create. When you are not painting, you should be able to imagine this feeling and bring yourself right back to that calm state of being, whenever you wish.

Don't over-do things. Sometimes when we start doing something new, the temptation is to go crazy and consistently repeat the same thing over and over again. This can eventually turn the once new and exciting experience into something more boring, seen as a chore. Paint frequently but try not to over-do it – a little in moderation is a great tip in life. Take breaks so that each new session is something to look forward to, not to avoid or put off to another day.

Do not complicate or confuse things. For example, do not add too many colours or too many shapes when creating. There are limits in all things we do. If we over-work we become tired, and if we put too much into a painting it can lose its beauty, becoming too fussy. Instead of being a simple journey, the creative process becomes one where every step is hard work, full of complicated decision-making which is what we are trying to avoid.

Simplify

To reach a quiet, peaceful painting zone we need no fuss. We just need clean fresh colour applied with a beautiful flow so that our painting time helps us reach an enjoyable and calm mental state.

Stress-free

Painting to change our mood should be relaxing – minus any stress. Paint purely to escape, just for a while, to somewhere only we know. Our own world. One we can invent, reinvent, leave or return to. We have that power and that choice.

It is that simple.

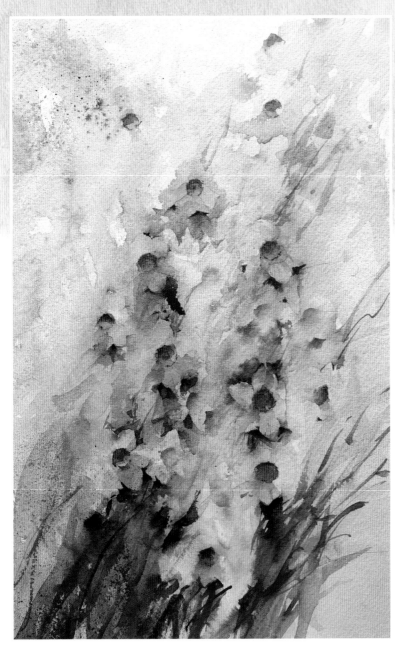

Avoid Complicated Confusion
38 x 57cm (15 x 22½in)

Lifting the mood

'Somewhere over the rainbow, bluebirds fly. Birds fly over the rainbow, why then, oh why can't I?'

The ballad *Over the Rainbow*, by E.Y. Harburg and Harold Arlen, has been sung by many artists and all over the world by people of all ages and nationalities. The lyrics about wishing upon a star to make all your dreams come true, with your troubles melting away, are wonderful.

When we paint, our troubles can also seem to temporarily disappear. There are times in our lives when painting can offer a much needed haven. I am not suggesting that running away from a problem is a good thing, but taking time out can be therapeutic. So what better way to discover which colours you enjoy the most than by painting a rainbow?

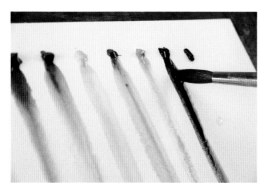

Try taking a piece of paper and applying each colour in the rainbow at the top of it, side by side in a row working from left to right. As you apply each colour, leave a small gap of white paper before adding the next colour alongside it. Paint the colours individually with downwards brushstrokes so that they form lines moving to the base of the paper.

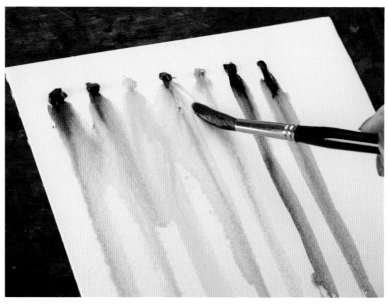

With a clean damp brush touch the gap between each of the last two colours applied so that they merge, before you move on to the next new one.

The rainbow

The value in each of the colours is important to our mood. Not only when we are using them, but when we are resting or waking. Try thinking about the colours as blankets to wrap around you whilst you sleep using the information on the facing page.

TIP

Red, orange and yellow are great energising colours to imagine when waking. But the exact opposite can be seen as true of the other colours in the rainbow. These are best used to imagine before going to sleep.

Red

A powerful colour that can be used to make us feel more energised. Before you wake each morning imagine being wrapped in a wonderful soft red blanket. If you are tired, it is a great spirit lifter. Take a few minutes absorbing the red colour before you rise to start the day.

Orange

Try imagining moving from a strong red colour in your imagination to a vibrant, glowing orange. Imagine fresh orange juice being squeezed from the fruit in wonderful sunshine, which should help you move in your imagination to the next colour.

Yellow

The colour of sunshine. Use this colour at any time in your imagination or when painting to create the feeling of warmth. Imagine the sun's rays falling across your face or shoulders. Yellow is a healthy colour, connected with a sense of wellbeing. Holidays do us so much good. So does painting in a colour relating to warmth; it that can lift our mood.

Green

The most peaceful of colours, used by interior designers to help with relaxation or for calming rooms. Imagine green fields stretching out as far as the eye can see. No buildings in sight. Just green.

Blue

A reminder of skies above us, blue is regarded as a colour that has a calming effect on the psyche, bringing with it a sense of healing wellbeing.

Indigo

Indigo is said to increase personal thought, enabling profound insights and understanding. A creative colour, it is particularly connected with those who love spontaneity.

Violet

Violet is said to create a balance between our physical and spiritual energy. Some believe this colour aids the imagination and spirituality, enabling us to get in touch with our deepest thoughts.

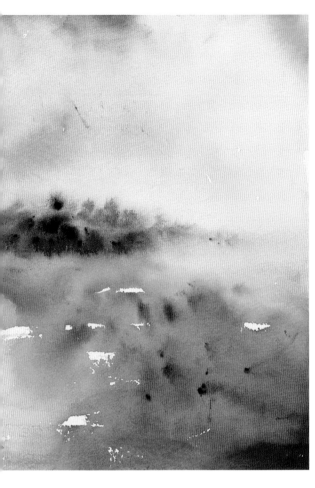

Colour connection

When all the colours are combined they can create a scene of beauty, but they can be used alone just as successfully. The most wonderful part of being an artist, or someone who paints for the sheer joy of it, is that you have the power to choose what colour you want, depending on what you need from your painting session. If you are finding it too hard to relax straight away, begin by painting in red shades and gradually move on to calming blue or violet. If you feel too lethargic, move from the blue and violet shades to stronger yellows or oranges. Finish your painting session by opting for the more calming green and blue colours; especially when you have free time immediately afterwards to enjoy and continue the wonderfully relaxed feeling.

'Learning about how each colour affects our mood can play a huge part in how we feel.'

Poppy Fields
28 x 38cm (11 x 15in)
Using all the colours of the rainbow can lead to stunning paintings like this simple scene of a poppy field in glowing sunshine.

Each minute we have to spend creating is valuable. Time – which we can't bottle or buy – is a treasure to be enjoyed and not wasted, so it is time to start painting simple calming paintings now. From here in, we will be thinking about the colour we use as well as creating.

I do not wish to turn this book into one of theory that takes hours to read, as I would prefer to keep the content simple, easy to follow and enjoyable. However, if you find this chapter fascinating, I would recommend further studying the way colour can affect our lives – as long as you do not allow the new-found knowledge to interfere with the calm way of painting that we are aiming to achieve. Too much information can distract from the goal of total relaxation, and our ability to switch off mentally when we need to.

Try working your way through the rainbow of colour when painting, taking time to think about how you feel when using each colour. Learn which are your favourites and which you prefer to avoid. Choose what makes you personally enjoy painting. Most importantly, choose colour so that you paint to relax. Let's paint our way through the rainbow next, thinking about each colour and how it affects us on a personal level.

Opposite:
Over the Rainbow
Colours merging together on paper can form wonderful patterns. Like seeing an unexpected rainbow, they can bring a brief moment of happiness that came out of the blue and then disappeared, touching you in a way that you cannot forget.

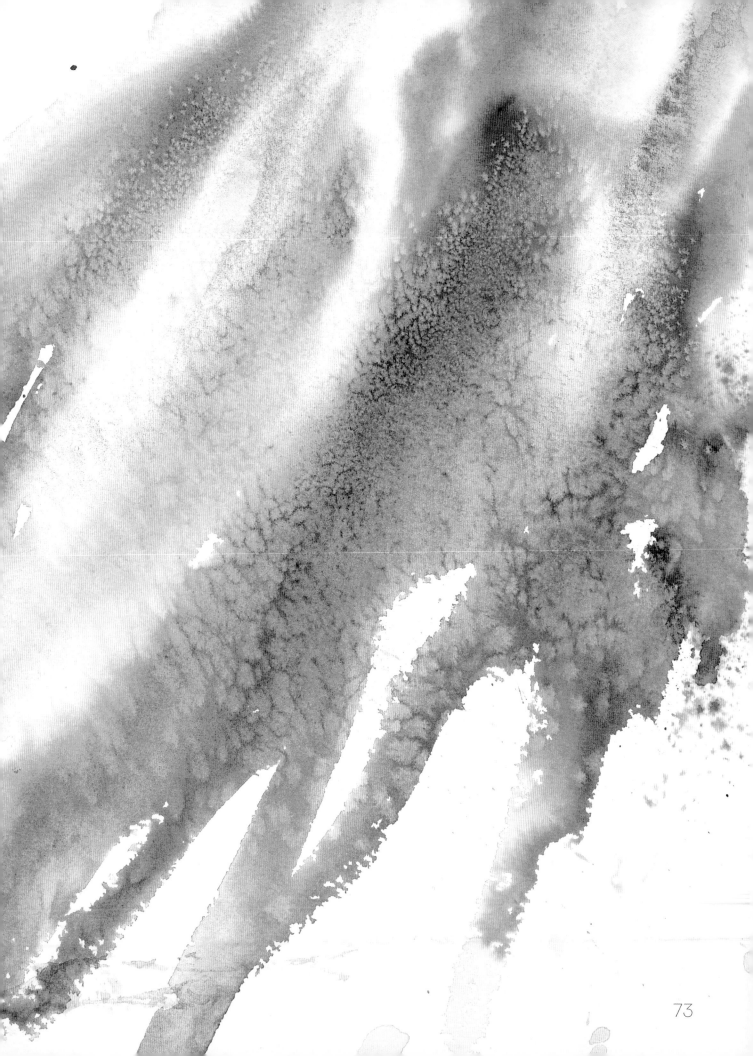

Finding energy and strength

'Time taken to put ourselves in a better and healthier state of mind is a blessing, and well worth it.'

Sometimes in life we feel nervous. We may lack confidence or courage, especially when faced with new challenges. These may be challenges life throws at us when we least expect them, or they may be challenges of our own choosing, such as taking up a new hobby.

Our daily routines can be so busy that we have little free time. We can also wear ourselves out by trying to do too much, so that we are too tired to do anything when that free time arrives. We can work to a point where it is almost impossible to relax, carrying tension in tightly knotted muscles. This is not healthy.

We know that exercise helps us stay fit, both physically and mentally. Active pastimes are fantastic, but not everyone is inclined – or able – to take up a sport or similar pursuit. However, everyone can paint – and relax by doing so. Painting can improve our mental state, leading to better lives. Through painting we can switch off from weariness and use colour to feel more energised. We can distract ourselves from problems and we can ease stress, even if the escape is only temporary. Time out is healthy. Time to put ourselves in a better and healthier state of mind is a blessing – and well worth it.

'Red is a powerful colour.'

It is the thought process that is important during 'colour-therapy creating'. If you think about red as a symbol of heat, and imagine it radiating through your body while you work, you can end a painting session feeling better than when you began. Only you have the power to tap into your inner artist and learn how to gain insight into control over your mood, tiredness and wellbeing. You can become a master in relaxation painting techniques, individually developed by, and for, yourself. Sometimes we need to place ourselves in a cheerful mood. At times like these, opting for a mood-lifting colour is wise: a vibrant, energising red.

Painting to feel energised

Let's start by covering a whole piece of paper with colour in a way that allows it to flow easily and interestingly. Each time you paint like this, you will achieve different results, which is the magic of watercolour.

As with the earlier exercises, you need only a few things: two colours – one red, one orange – along with a piece of watercolour paper, a brush and a little salt. Start by applying red colour across the top of the paper, and work sideways along the top, applying colour and water alternately. Wherever and whenever you wish to – you choose.

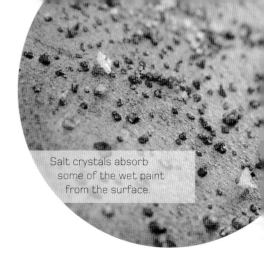

Salt crystals absorb some of the wet paint from the surface.

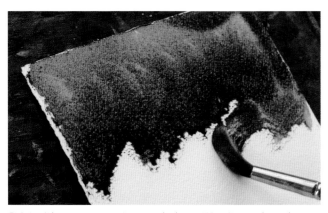

Paint with your paper at an angle, by putting it on a board leaning against something. This will help the colour flow downwards to form patterns as you paint.

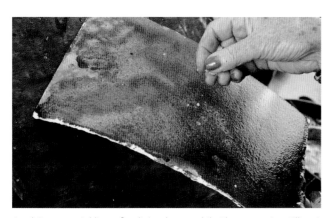

Applying a sprinkling of salt in places while the paper is still wet with the orange and red paint will form interesting patterns as the pigment dries. Fine salt will create fine patterns while rock salt will create larger ones.

The dotted pattern is created by the salt as the paint dries. Drops of water have pushed pigment out of the way to form interesting effects.

The salt needs to be removed once the paper is totally dry – this will reveal the patterns created by its application.

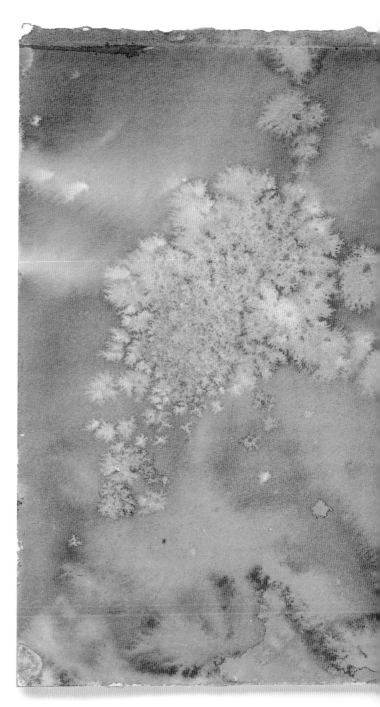

Taking time simply to observe

Look at the patterns of red paint and think about what you have just achieved. Think of heat when you look at the red colour, and allow that warmth to flood inside you as you paint. This will give you a sense of energy and a feeling of wellbeing.

Look at the application of water and think of it as erasing tiredness – as though you were immersed in a luxurious, relaxing bath full of aromatherapy oils. Let the water flow through the red pigment and push every ache or problem away. Watch the paper as the colours dry and allow yourself time to do so.

Paint a few pieces like this each time you feel tired, but please don't rush them. Try to deliberately take your time with each new application of colour and brushstroke. Teach yourself to paint slowly to enjoy the experience. If you are a person who finds relaxing or working slowly difficult, set yourself a challenge to make each result more interesting than the last by taking time to think how you can do so.

Important

Do not treat your painting time as some form of race or the relaxation benefit that can be gained from creating will be totally lost.

Painting a subject

Painting just with colour is far more relaxing than having to paint a subject. For some, subjects can bring stress, but others find having a subject to work with much easier as it gives a definitive form to reach for. Paint what makes you happy – either abstract colour or subjects that please you. It is most importantly that all of your painting time is thoroughly enjoyable and stress free.

Having experimented with red as a colour, how about painting a giant poppy? For this you will need the same red and orange shades used in the example on page 75, but also a dark blue for the flower centre, and some salt. I use rock salt as I like the way the larger granules form stunning patterns with watercolour.

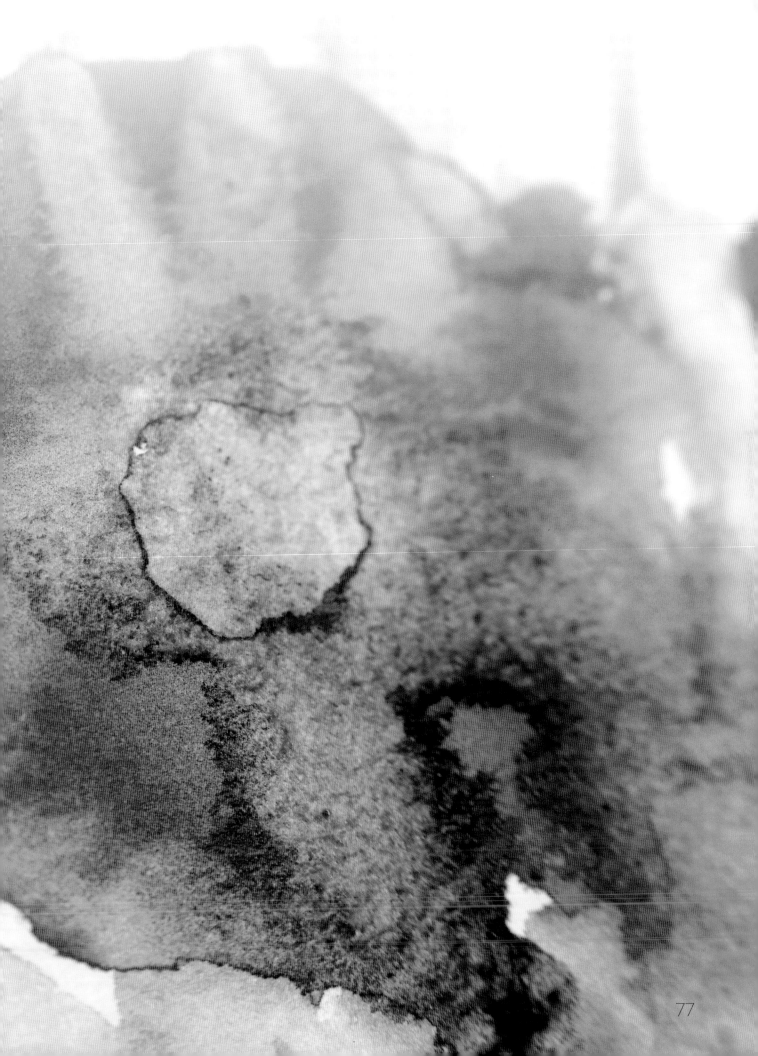

Giant Poppy

'In life we cannot always be in control.'

Imagine you have a huge problem, or that you have been working too hard. The centre of the poppy represents this. The radiating red colour takes away from the problem and flowing water moves the energy to a more positive outcome.

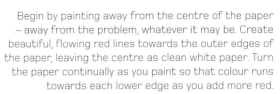

Begin by painting away from the centre of the paper – away from the problem, whatever it may be. Create beautiful, flowing red lines towards the outer edges of the paper, leaving the centre as clean white paper. Turn the paper continually as you paint so that colour runs towards each lower edge as you add more red.

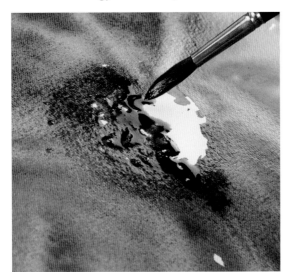

When the whole of the outer area is covered in red colour, add the blue centre. Please don't try to be neat. Let the colour do the talking on its own. In life we cannot always be in control, and in painting we certainly don't need to be. When we create, we need to learn to relax and simply enjoy what is happening when colours flow and merge.

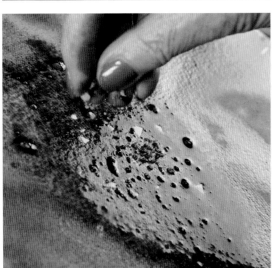

Don't worry if the newly applied blue colour merges with the red outer edges in places. This is what watercolour does and it is beautiful when left alone to dry naturally.

Place salt in the centre section while the colour there is still wet. Later on, when your painting is totally dry, you can remove the salt simply by pushing it off the paper with your fingertips.

Form petals by applying water or fresh pigment around the centre, but try to leave this painting as simple as possible. Detail can be added if you wish to turn this into a different kind of painting, but the aim here is simply to relax and feel good through playing with red colour.

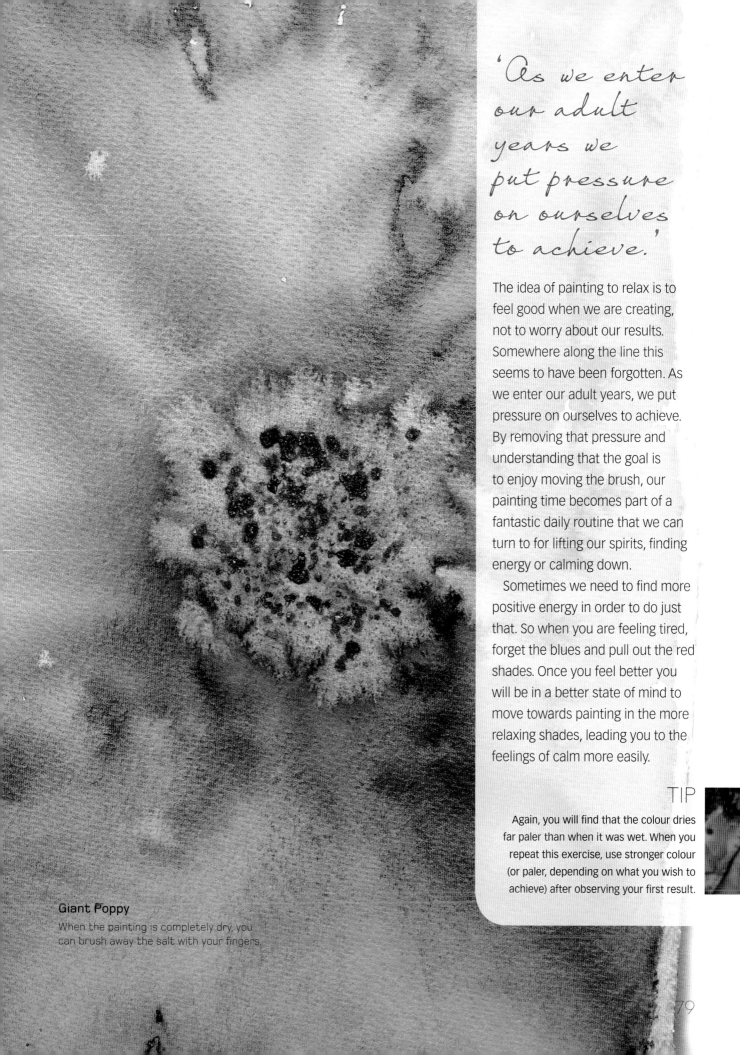

'As we enter our adult years we put pressure on ourselves to achieve.'

The idea of painting to relax is to feel good when we are creating, not to worry about our results. Somewhere along the line this seems to have been forgotten. As we enter our adult years, we put pressure on ourselves to achieve. By removing that pressure and understanding that the goal is to enjoy moving the brush, our painting time becomes part of a fantastic daily routine that we can turn to for lifting our spirits, finding energy or calming down.

Sometimes we need to find more positive energy in order to do just that. So when you are feeling tired, forget the blues and pull out the red shades. Once you feel better you will be in a better state of mind to move towards painting in the more relaxing shades, leading you to the feelings of calm more easily.

TIP

Again, you will find that the colour dries far paler than when it was wet. When you repeat this exercise, use stronger colour (or paler, depending on what you wish to achieve) after observing your first result.

Giant Poppy
When the painting is completely dry, you can brush away the salt with your fingers.

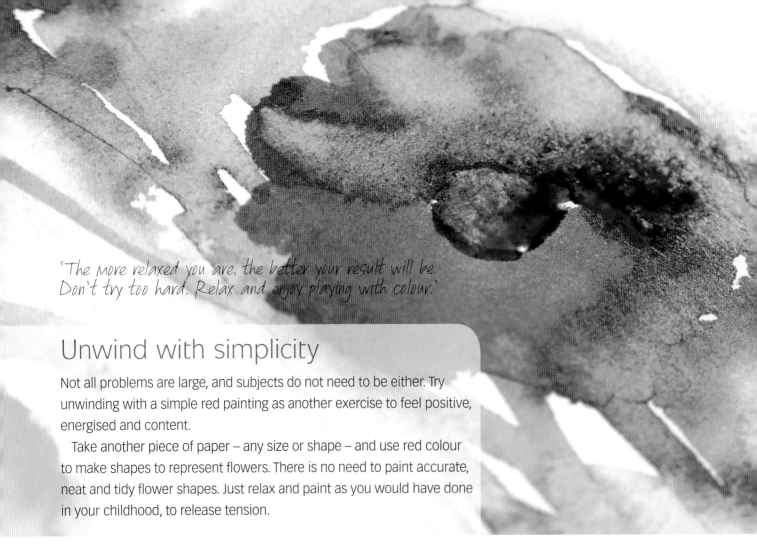

'The more relaxed you are, the better your result will be. Don't try too hard. Relax and enjoy playing with colour.'

Unwind with simplicity

Not all problems are large, and subjects do not need to be either. Try unwinding with a simple red painting as another exercise to feel positive, energised and content.

Take another piece of paper – any size or shape – and use red colour to make shapes to represent flowers. There is no need to paint accurate, neat and tidy flower shapes. Just relax and paint as you would have done in your childhood, to release tension.

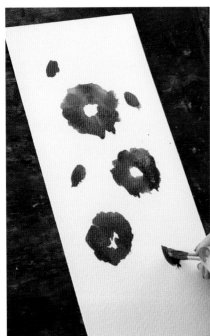

Remember the golden rule is to simplify. No complicated individual petals, just easy colour shapes at this stage. You can add red shapes for buds in between the flower shapes.

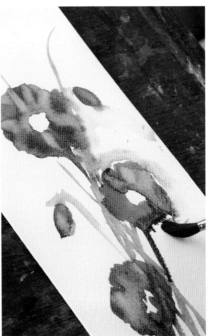

Wetting sections of paper around the already painted and still-wet poppy shapes will blur some of the edges. Try adding a few fine lines in between the flowers as hints of stems. Don't feel they need to be green. Staying on a red theme will look beautiful and keep you in the red zone of relaxation.

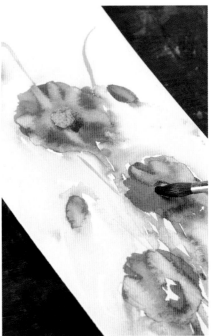

When adding the centres with dark blue, you do not need to make them all the same. Just add colour in each flower shape. Don't worry if the colours merge, as that will add to the unique beauty of your finished painting.

Repeat with imagination

Beautiful effects are achieved by allowing colour to merge with water when painting these simple poppies. If you enjoyed the process, repeat it whenever you want to.

Better still, when you close your eyes, imagine a whole field of poppies with their heads gently dancing in the breeze. Feel their gentle movement and aim to portray that in your next brushstrokes of the same painting.

Red instils a feeling of energy, confidence and power

Red is a feel-good colour. I know because my paintings that have red in them usually sell first at an exhibition. People like red. It instils a feeling of energy, confidence and power. It is a happy colour that cheers us up and is pleasant to have on a wall. But when you come to understand that you can feel all these emotions simply by painting with red, then the colour really does carry a whole new meaning. It energises us and make us feel better.

Do not underestimate the value of painting with the right colour at the right time in your life. If you need energy or confidence, work in red.

Bear in mind that this colour will not always aid relaxation but it certainly can lift your spirits and take you out of a depressed or low mood. Red cheers – and what a great way to gain a smile or happy feeling!

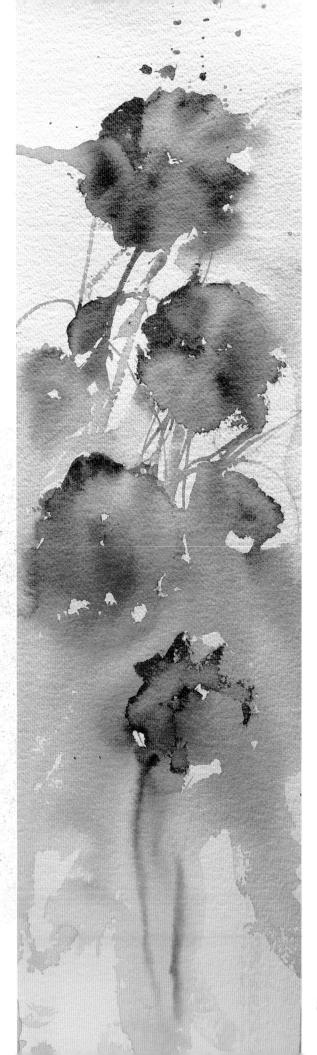

Sands of time

'We sometimes need to put ourselves in a happy place mentally before we can even begin to think about relaxing.'

In many ways simple pleasures are the best. We can easily forget the joy of paddling in the sea for the first time or how excited we once were at finding shells on the beach.

Early memories from childhood can be beautiful for some, while for others they may not be. I believe that life is too short to dwell upon what happened in our past, as the present and future are gifts not to be wasted. We need to learn to let go of anything negative.

Over the years I have discovered that painting is my constant companion, through good times and bad. Painting can guide us to a peaceful zone where everything else that may be stressful appears to be less so.

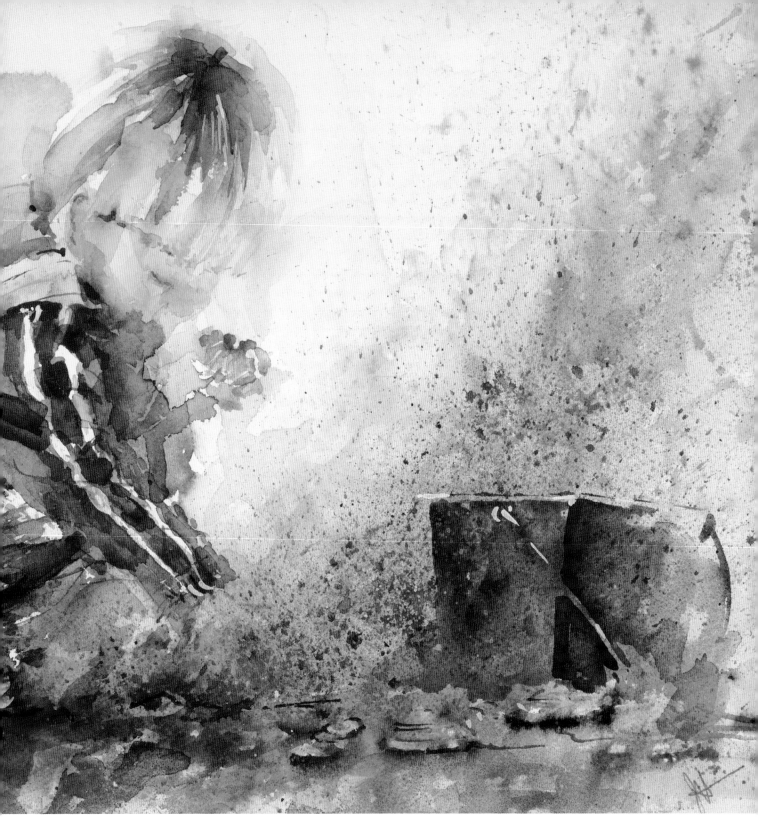

Finding treasure

32 x 40cm (12½ x 15¾in)

The simple joy of playing on the sand as a child is somehow
lost when we become adults.

Time flies when you are having fun

I used to love taking my children to beaches and watching them innocently searching for treasure. When I lived in Dubai we owned a huge Bearded Collie dog called Taffy. He came with us every time we moved as I couldn't bear to leave him behind.

I adored our huge shaggy companion and he was by my side constantly. Each morning I would wake and drive him to a quiet deserted beach on the coast before the sun became too hot to bear. I would walk the length of the beach with him and return late at night when it was cooler. I remember vividly the colour of the sands and the beautiful sea disappearing into the horizon. I would casually pick up sea shells. Taffy became so fascinated by my search for treasure that he also joined in and often found the best shells, with his huge Collie nose up-ending them for me to see.

I cannot imagine walking along a beach at five in the morning every day now. But we do many things for love and my dog couldn't walk in the midday heat. I still have these same shells and cherish each one. They hold memories of happiness

Simple things in life are often the most beautiful. So for this section I would like you to think of your happiest memory and try to match it with a colour.

Golden colour

'It is hard to think of sunshine without smiling.'

When we think of gold as a colour we imagine tall sunflowers with their heads turning towards a bright yellow sun. It is hard to think of sunshine without smiling. I close my eyes and can easily imagine the sun's rays on my face. This is such a gift as I live in England, where it rains more than the sun shines. Maybe that is why I love painting in golden shades so much – to distract my mind from the grey skies I often see here.

I love the song *Sunshine on my Shoulders* by John Denver. I have loved folk and country music for years and the lyrics to this song in particular always make me smile, without fail.

'Sunshine on my shoulders makes me happy'

The words are perfect. If ever I face a grey day – either due to bad wet weather, or a storm in the form of stress or one of life's challenges – I paint in bright golden shades. As an artist I can change the season in my mind at any time, simply by choosing to paint in a colour that is cheerful and bright, which in turn lifts my mood. You can do this too.

When going through difficult times, it can be hard to reach a peaceful zone in our mind. This is why we sometimes need to put ourselves in a happy place mentally before we can even begin to think about relaxing. You may find at times that working with obvious shades, such as blue or violet to relax, does not work. This is when you can try covering a piece of paper with a warm golden colour as an alternative.

Simple beach painting

You will need to work with golden yellow colours for this. A gorgeous shade called quinacridone gold is a fabulous 'feel-good' colour. Yellow ochre is another wonderful colour that works beautifully for beach scenes.

As you paint the sand, imagine walking along a beach barefoot, feeling the smooth warm grains under your feet. Please note that your painting should not be raced through if you want to open your imagination and really feel the sunshine creeping into your painting session.

You do not need a sea shell for this demonstration, but if you have one then you can use it to paint around. Start by placing your shell on the paper and applying colour with your brush around the edges. If you do not have a shell, you can invent a shell outline and paint around that.

Let the golden colour flow across the paper in a downwards diagonal direction as you paint around the shell. As you do so, imagine the tide coming in and out.

Try adding water on top of the glowing colour around the shell. This can be seen to represent the action of the sea. It really is so peaceful watching colour move.

Sprinkle salt on the still-wet pigment surrounding the shell and then, if you wish, you can spatter some orange or gold colour onto the paper with a toothbrush to create even more fascinating patterns.

Leave until completely dry, then carefully lift away the shell.

Happy memories

It is strange how memories flood into your mind when you paint. Just writing this chapter took me back to a game my grandfather used to enjoy showing me when I was little, which was to take a coin, paint around it and then paint the detail inside the remaining white paper shape. This was complicated as the detail was quite intricate, but you can paint around something simpler. Autumn leaves are fantastic to use as they give fabulous shapes and lead to wonderful results if you choose vibrant glowing colours to create with. You can paint around absolutely anything at all, so set yourself challenges to think about something new to try each time you paint. Keep things simple so that your mind can focus on colour and its connection with a subject, season or emotion in a way that helps you feel peaceful.

If you wanted to, you could create a large beach scene with many shells of different sizes in it, taking your time and adding one shell at a time. Look forward to building up the painting gradually, taking as long as you need so you always enjoy the creative experience.

Of course oranges and golds can be used as a colour to paint so many subjects – flowers, glowing fields of corn just waiting to be harvested... The ideas are endless. But for now it is time to move to yellow, the colour of the sun.

Colour from the sun

'So often in life we try too hard, and that effort takes away the enjoyment of doing something simply for the sheer pleasure of doing it.'

Happiness, sunshine and cheerfulness – these terms are related directly to the colour yellow. For many, a dream holiday is somewhere warm in the sun, especially if you live in a cold climate or a country that is prone to heavy rainfall. Taking a holiday when and where we need it is not always possible, but if you paint you can go anywhere you wish to via the stroke of a brush. Better still, you can paint instant sunshine when the weather outside is looking dull or grey.

It is a well-known fact that sunshine makes people feel better. It lifts spirits. It can ease pain if you suffer from arthritis. It tends to make people smile. It can instantly put us in a better mood.

This chapter looks at ways to create a glow simply by imagining sunshine on our skin. Before you even start painting, close your eyes and try to imagine sunshine hitting your face. Feel glowing sun rays of warmth flowing over you, seeping into your soul and warming your spirit. Hold these thoughts, and now try to pull them into your painting.

Capturing the sun

All we need is a large piece of watercolour paper, four colours – yellow, orange, gold and purple – a brush, water, salt, and plastic food wrap. Squeeze small dots of colour for the centre of the flower into the centre of the paper. Then squeeze one or two dots of yellow at the outer edges of the paper, and begin...

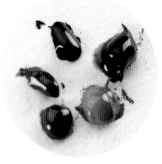

Begin to paint by using your wet brush to encourage the yellow from the outer paper edges to flow in directional lines towards and away from the centre.

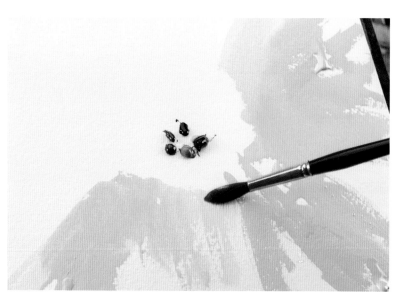

Create the centre of the sunflower by using the initial dots of colour placed here. Use water only to move the colour that is already in place. Do not worry if the central colours flow into the outer yellow colour in places.

Once you have painted the centre of the flower, you can sprinkle salt there while the colour is still damp in order to form interesting patterns, if you wish.

Placing a layer of plastic food wrap on top while the yellow colour is still wet, and pushing it with your fingers, will form petal patterns underneath.

Try painting a huge sunflower next, keeping it really simple, as with the exercise on the previous pages. Take a large white piece of watercolour paper and enjoy covering it with yellow colour, forming patterns and experimenting with a variety of centres. You could combine what you learned from the exercises found in previous chapters to escape to a whole field of sunflowers, in glorious sunshine under a bright blue sky.

Even when you are not painting, imagining this colour can help you feel good. Simply use your imagination to keep the glow alive in your mind. In fact, next time it rains, try painting instant sunshine.

Under the Sun
38 x 28cm (15 x 11in)

Healing herbs

'Herbs can aid relaxation, leading you to a wonderfully rejuvenated and alive state of mind.'

Throughout history, herbs have been used for medicinal purposes, in cooking, and as an aid to relaxation. Since my teens, when I was told about parsley being a natural cure for headaches, I have been hooked on learning more about them.

I add a mixture of herbs to a bath for de-stressing. I place bunches in laundry baskets and cupboards to keep linen smelling fresh. Mint is fantastic to give a natural fresh fragrance to a room, as is rosemary. I always have a section of my garden devoted to growing herbs. Not everyone has access to a herb garden, but growing herbs in pots in the kitchen is easy and a great way to keep an abundant supply at hand. Of course, I use them to cook, but I also regularly pick bunches of herbs to place in my studio which aid my painting sessions. They help me relax and keep me in a wonderfully rejuvenated and alive state of mind. I take the fascinating knowledge of working with herbs into my painting experiences.

Most herbs are green. I must confess I find green a favourite colour. I always have. Well, that's not quite true, because as a child my stepmother believed children with red hair and green eyes should wear green and at that time I wasn't so in love with the colour as I am now! Times have changed and I wear it often. Some believe it is a lucky colour and I find it to be so for me. As we are working through the rainbow of colour in this section of my book, green herbs become a great source as a subject, as well as having qualities I use when painting.

So I am now going to encourage you to do a little homework on herbs and discover which could suit your needs best while creating. They all hold different properties. For this chapter I will look at mint and rosemary.

'We have the power and the freedom to paint whatever we like, when we like, as we like.'

If you look at a colour chart to buy a shade of green you can easily become lost or overwhelmed with the variety available. That is because it is a very popular colour for artists. Why? Try painting a landscape or a floral composition without green in it! There are blue-based greens, yellow-based greens... so many to choose from and we will all have our favourites. This brings me back to the point of this book.

Only we know what we like, only we know what our favourite shades will be and no one should dictate what they are. We have the power and the freedom to paint whatever we like, when we like, as we like. Always.

We have control, which is a great word. As a child and teenager I felt I had no control over what was happening to me. It has taken years to fully understand that I do have that power as an adult. I can choose what I want to do, when and how. If only we all realised we have that power earlier rather than later in life.

For the exercise on the following page, I would like you to find a herb to work with. Take in its fragrance before you start painting. If you are working with rosemary, for example, crush some of the small twig-like branches. Breathe in the wonderful aroma from your fingers and then start painting. Place a bunch of rosemary near your painting space, so you can take in the scent easily.

Paper backgrounds

For this demonstration I used a scrap of watercolour paper that had colour on it. The colour already there made a beautifully natural background for a painting of herbs.

I keep all scraps of paper I have painted on so that I can use them in this way. It means I do not waste paper and always have scraps of coloured paper at hand on which to paint. This makes my painting time more interesting.

Painting shadows

Take one sprig of a herb. Place it over a piece of paper and look for the shadow it creates – this can be achieved either in strong sunlight or through artificial lighting. Now all you have to do is paint the shadow where it lies to create your painting. I like to think of this as taking negative dull shadows and turning them into something positive – just as life's hiccups can make us stronger if we overcome them successfully.

Next, paint the shadow. This technique is so simple and you can use it for so many subjects – try painting a number of herbs or flowers this way. It is simple and leads to effective results. But when creating to feel calm, don't overcomplicate your painting time by adding too many herbs or too many details. Keep simplicity in mind. Aim to paint just one herb at first, taking in the fragrance as you paint.

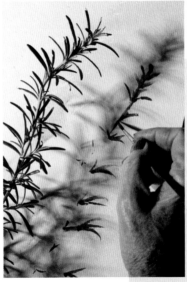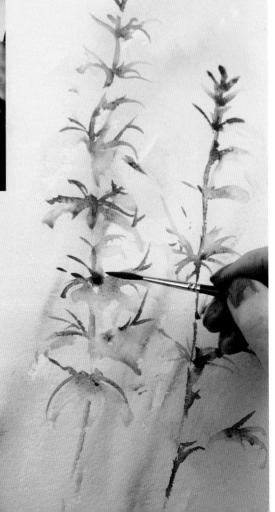

Cast the shadow on the surface, then simply paint the shapes you see.

TIP
Keep a box containing scraps of painted paper for exercises like this.

When you have finished painting, compare your result with the real thing. Take time to observe how you have worked. Is the colour application of your painting too heavy? If so, learn to be more gentle with both colour and your touch when you paint next. Perhaps there is too much detail making your painting too fussy? If so, try again but more simply.

While you do, think about how you can simplify your life. Learn to prioritise. What is important and what isn't? I find the quality of my life has improved by learning from what works and what does not in my paintings.

Keep it simple

It can be hard to relax when life becomes over-complicated. Painting is exactly the same, so simplify whenever possible.

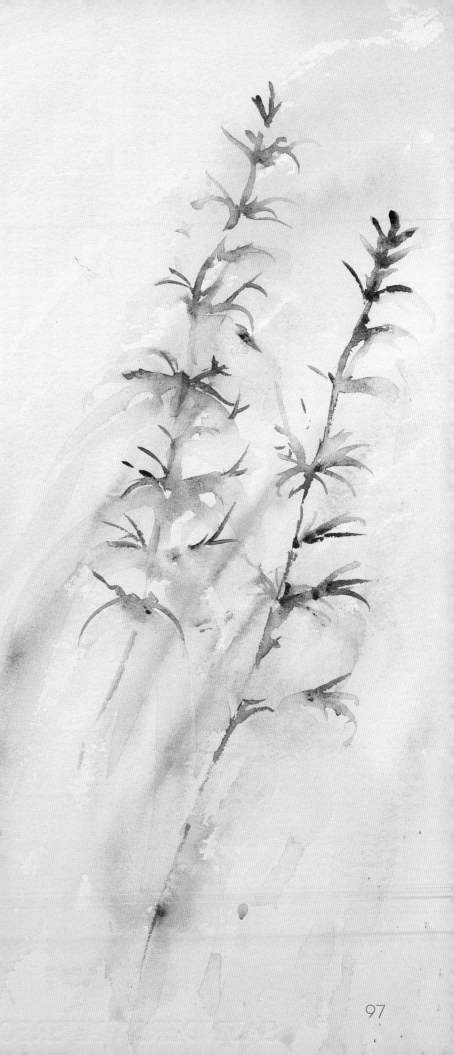

'There is far more to be gained from painting than the end result of colour on paper.'

Painting is a form of relaxing therapy

There is far more to be gained from painting than the end result of colour on paper. Painting as a form of relaxing therapy can be beneficial if we explore how to improve our creative time. Use of essential oils, scented candles or calming music can play a part in helping us reach a calm state while moving our brushes. Try choosing different herbs to paint and discover how each can help you.

For example, rosemary is said to improve concentration. Research has indicated that rosemary oil can increase alertness and enhance your long-term memory. Shakespeare used rosemary in *Hamlet* as a symbol of remembrance and memory. If you are feeling tired or depressed, mint in its natural form or as an essential oil is said to bring relief. Herbs can be useful additions to a painting session where you need to relax.

Setting yourself new relaxing challenges

Try other experiments using the demonstrations in previous chapters by painting a whole garden of herbs. Create a green wash as a background, then paint a few herbs on top, taking in the fragrance of the genuine article as you work. Leave your painting session wonderfully relaxed.

Learn about the healing effects of herbs and set yourself a challenge of painting a new relaxing plant each week. Plan a month ahead of one herb per week with the goal of relaxing while you create. Enjoy the discovery and journey into the new knowledge you gain when doing so – and have fun painting.

'Painting with or being surrounded by green can be so calming.'

Nothing but blue skies

'When painting the emphasis should be on the joy of creating and allowing colour to flow freely.'

I have heard that in healing terms, the colour blue can be used to open blocked energy flow. It is also said to represent heaven. To me the colour blue represents life without problems, especially in clear blue skies. No storms, no rain. Just perfection. However, it is also said that clouds can create the most beautiful patterns and there is nothing more relaxing than watching their shapes form and move.

To be a good landscape artist there is a saying that you need to paint at least one sky a day. The only way to do this is to be good at observing cloud formations and the colours in the sky. You do not need a reason to stand still and simply look at the sky. It is amazing how many people rarely take time to look up. We should do so more often.

To paint skies, we need to choose a good colour and there are many wonderful blue shades to choose from. Cobalt blue used to be a strong favourite of mine for painting skies but now I am happy to use any blue at all as long as it makes me feel happy and at peace – just as I would be on a beautiful summer's day enjoying the sight of a clear blue sky which is simple enough to paint. Here are two ways to paint with blue. One is creating a sky effect, the other is a more relaxed method of using colour simply for the fun of it to unwind.

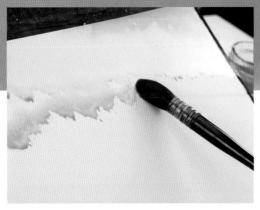

Try gliding the colour across the paper. Aim to allow the blue to flow rather than be controlled. You may also find it easier to use a larger brush.

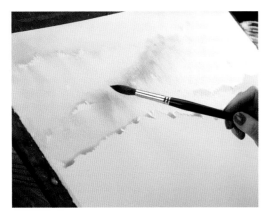

You can choose to create cloud formations by leaving sections paler and working around them – or you can opt to leave whole white sections on the paper and work around them with your blue colour.

Painting the sky

To do this you need to prepare by actually observing the sky. Think about the colour you see and the patterns formed in it by the clouds – if there are any – and imagine how you would wish to capture them on paper. Keep your painting time calm and simple.

Try using a larger piece of paper to paint your sky. This way you can feel the freedom of moving your whole arm which in turn is restful and brings with it a great sense of liberation.

Start by adding colour to the top of the paper. Work from one side of the paper to the other, allowing the blue colour to flow gently as you add either more pigment or more water. Feel relaxed and think about how your arm is moving as you paint.

Whatever colour sky you are painting, take time to look at the real thing and observe its colour and the patterns in it that are created by nature. In life we tend to miss so much that is right in front of us as we race from one day to the next. The gift of sight is one to be appreciated. If we wish to relax and enjoy painting from nature, we need to instil in ourselves the ability to see everyday things and not take their beauty for granted.

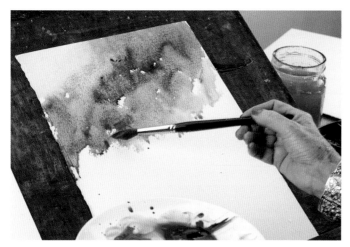

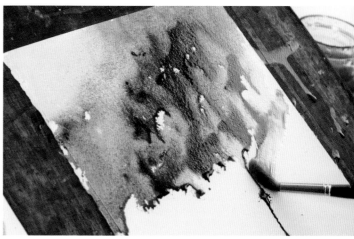

Add colour where and when you feel it looks the most beautiful – just for fun.

Clear water pushes the paint away, just like you can push your problems away.

Painting with freedom

Painting can be the most enjoyable of ways to pass time, bringing us a strong sense of satisfaction and by doing so making us feel happier. Just letting go of the idea that we have to paint anything at all is important. The emphasis should be on the joy of creating and allowing colour to flow freely.

Try this wonderful way of working with colour, which can be more exciting than aiming to create a serious painting. Here we are literally pouring colour onto paper and feeling the carefree abandon that a child may possess when working with colour – no inhibitions.

Take a small white plate and place some blue colour on it, then add water to form a large puddle of colour. You will be using this to work with. At the top of a large piece of paper, begin painting with the blue colour from the plate.

When painting this time, drop clean clear water from your brush, and allow it to push the blue colour already on the paper out of the way to form gorgeous patterns. Think about this action as pushing any problems out of the way. You have control and this action is freeing, enjoyable and relaxing.

Now for the more fun part. Pour the colour from the saucer onto the still-wet paper. I love doing this. Watch what happens. If you need to, shake the paper at times or hold it at an angle to encourage the most beautiful of colour flows. Watch the colour dry and see what patterns form as it does so.

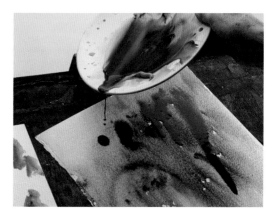

Enjoy pouring the paint directly onto the paper from your plate or palette.

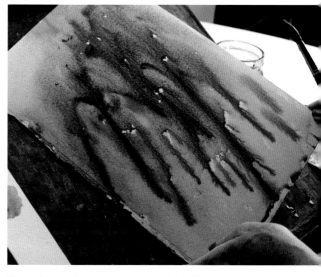

Tip and turn the paper to control the flow.

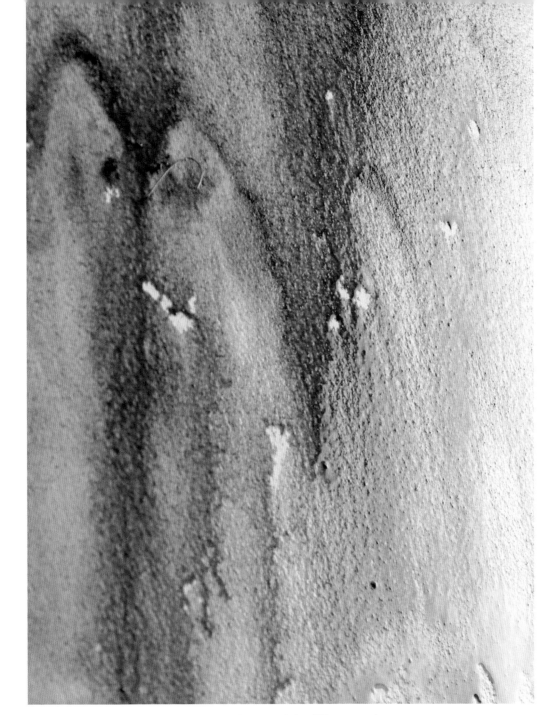

I paint two to three washes like this daily, each in different colours, and it is now part of my routine. Afterwards I feel energised or relaxed, depending on the colours I select to work with. I always use blue when I need quiet time to unwind – you can too.

Brilliant for calming the soul and a great way to release tension, playing with colour this way will help you achieve completely unique results every time. It is a form of abstract painting.

Blue

Blue is the colour of awareness, healing, and relaxation. It is quite literally all around us in the skies we see. Blue is beautiful, calming and relaxing – and a wonderful colour to paint with when you need to unwind.

Healing lavender

'Using specific colours when painting can aid relaxation, bring peace of mind, and encourage a sense of calm and wellbeing.'

Lavender is used in so many healing products, especially aromatherapy oils. It is widely used to help with relaxation. Rubbing lavender oil on your forehead is supposed to ease headaches and aid sleep. I have always loved placing a sprig of lavender from my garden inside a pillow case for this reason. I place sprays of these gorgeously scented plants against laundry as it dries on the line, knowing the scent will carry in the clothes long after they have dried and been stored away. Living in the countryside as a child I learned many country ways and this is one of my favourite things to do in the home. Lavender is a natural air freshener that makes one feel instantly calm and relaxed.

I love the properties that this plant has so much that I use it regularly whenever possible, and paint with the colour for the very same reason.

Think about the colour of amethyst. As a semi-precious stone it is said to soothe the mind and emotions. Imagine if you could take this power of healing into your time when painting. Imagine watching colour flow with a lavender-scented candle or oil surrounding you as you paint. You could create your own health spa – at any time whenever you wished. Add to that by playing relaxing music as a soft background. In fact, set up your painting session deliberately for personal space. Plan a set time each week to paint something really relaxing and look forward to it. Enjoy it without interruption so that this becomes a routine part of your life that is all about you, your relaxation and your wellbeing. You deserve it – and if you don't give quality time to yourself, who will? I think we often look after everything and everyone around us far more than ourselves.

This chapter is about using colour, scent and time to relax and feel calm.

Let's paint!

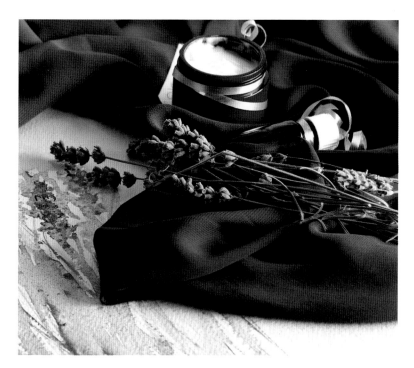

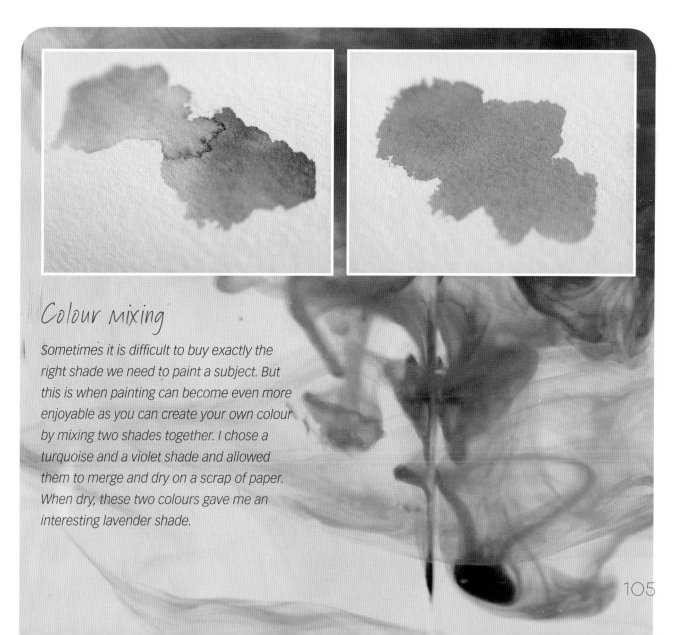

Colour mixing

Sometimes it is difficult to buy exactly the right shade we need to paint a subject. But this is when painting can become even more enjoyable as you can create your own colour by mixing two shades together. I chose a turquoise and a violet shade and allowed them to merge and dry on a scrap of paper. When dry, these two colours gave me an interesting lavender shade.

105

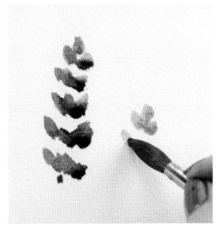

Painting lavender to relax

If you have lavender growing in your garden, it is ideal to use to look at and see how to paint it. If you don't, you can work from photographs easily found online – and you can follow my simple step-by-step guide here to help you. All you need for this exercise are scraps of watercolour paper, a brush and one each of purple, blue and green shades.

Using a beautiful purple shade, start by painting simple lavender flower shapes. Leave some sections blurred, with the water merging with the colour. Next, add some stems moving downwards leaving the flower heads and working towards the bottom of the paper. Finally, add greenery at the base of your painting if you wish – or keep these lines in a similar lavender colour to create harmony in your results.

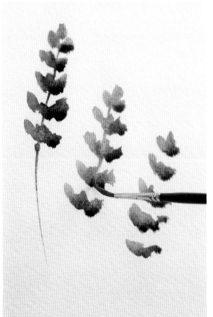

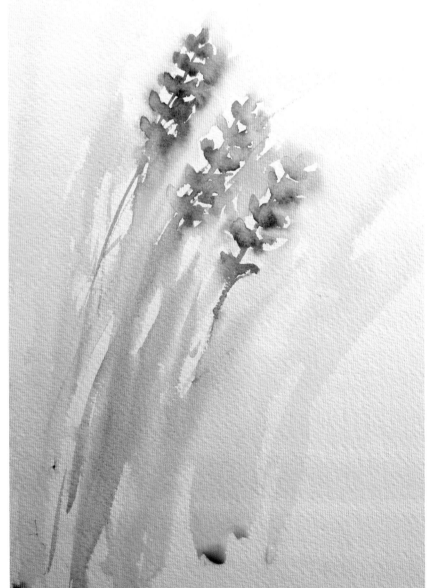

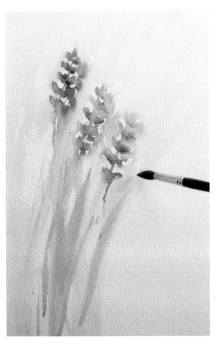

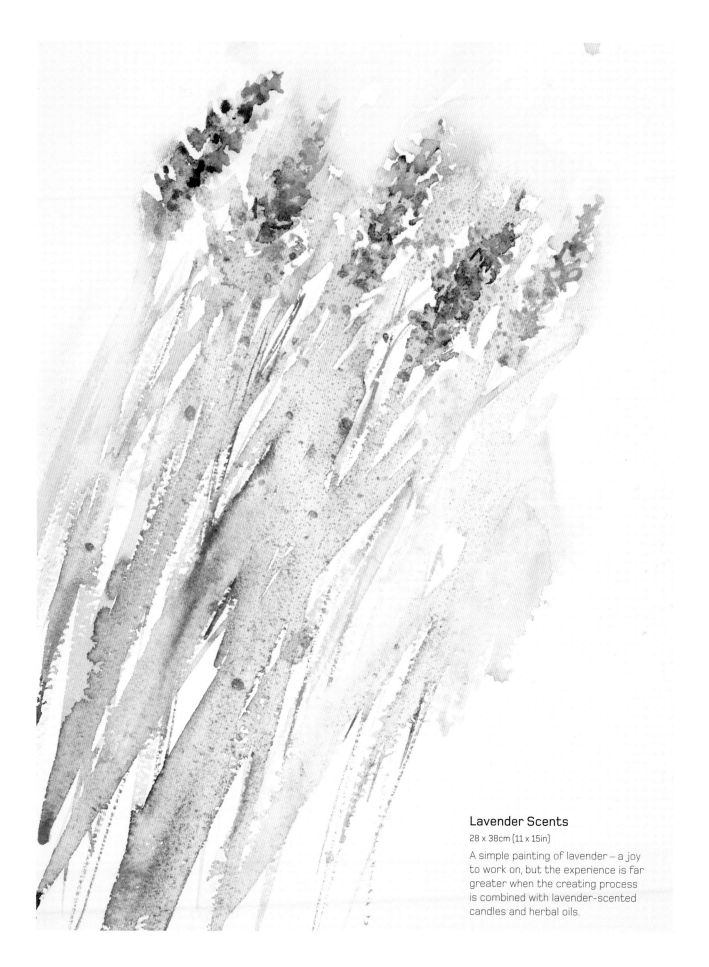

Lavender Scents

28 x 38cm (11 x 15in)

A simple painting of lavender – a joy
to work on, but the experience is far
greater when the creating process
is combined with lavender-scented
candles and herbal oils.

Consider taking a break from this book before moving onto the next section.

When you sleep tonight, imagine being surrounded by healing lavender fields. See the purple shades of glistening amethyst in your imagination and drift off to a peaceful sleep. Use painting to calm yourself even when you are not moving your brushes. It becomes a wonderful way of life when you do. It is simple, therapeutic and soul-lifting.

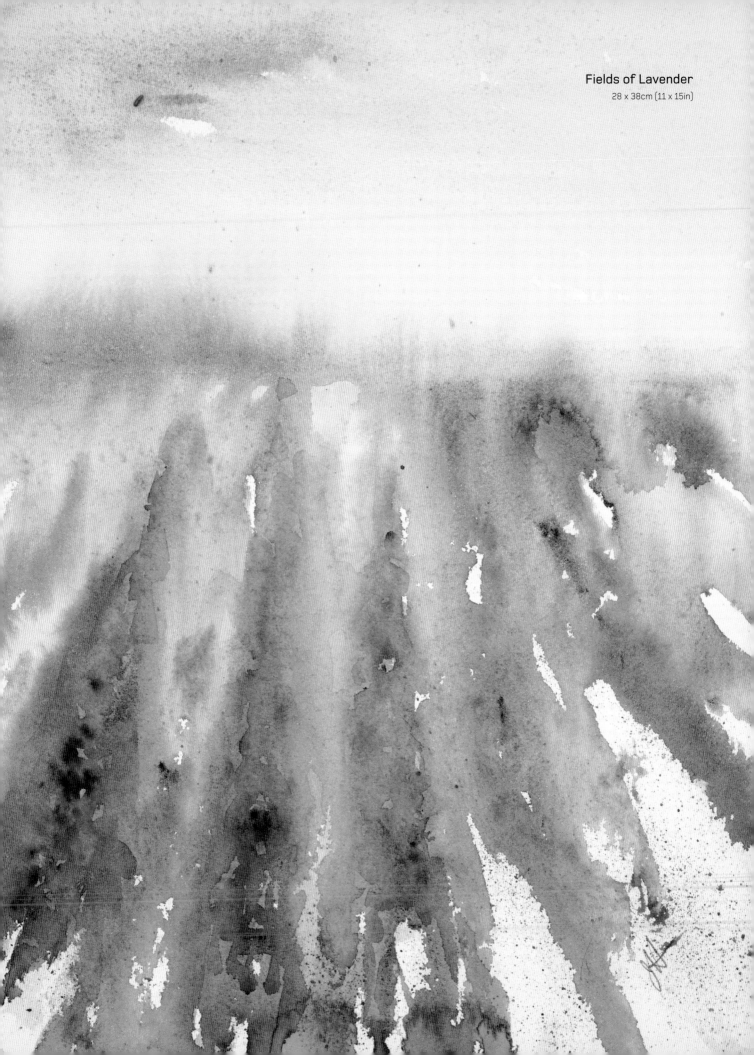

Wellbeing

'When painting with purple shades I can reach my peaceful haven, my quiet zone, more quickly than when I paint in any other colour.'

Working with any purple shade always reminds me of amethyst, which is said to have healing and spiritual properties. In Seattle, USA, I visited the head office of the watercolour paint manufacturer Daniel Smith, where I observed watercolour pigments being made. Their paint amethyst genuine is created out of genuine amethyst crystals and is very beautiful.

Amethyst holds a mysterious appeal and has been popular for centuries. Some claim it is helpful to have an amethyst near you, which is why believers in healing gems carry crystals. It is said to be a potent stone for spiritual healing and growth, and to help beat addictions. All I know as an artist is that when painting with purple shades, I can reach my peaceful haven, my quiet zone, far more quickly than when I paint in any other colour. Just moving purple pigment across paper is calming and healing to my mind, especially after a hugely busy day. This is why it is the most appropriate colour to close the peaceful zone section of my book.

I believe we can push problems away temporarily when painting. If we are fortunate enough not to have any troubles, painting to relax is easier. For this closing part of our journey through the colours of the rainbow I am going to merge indigo and violet.

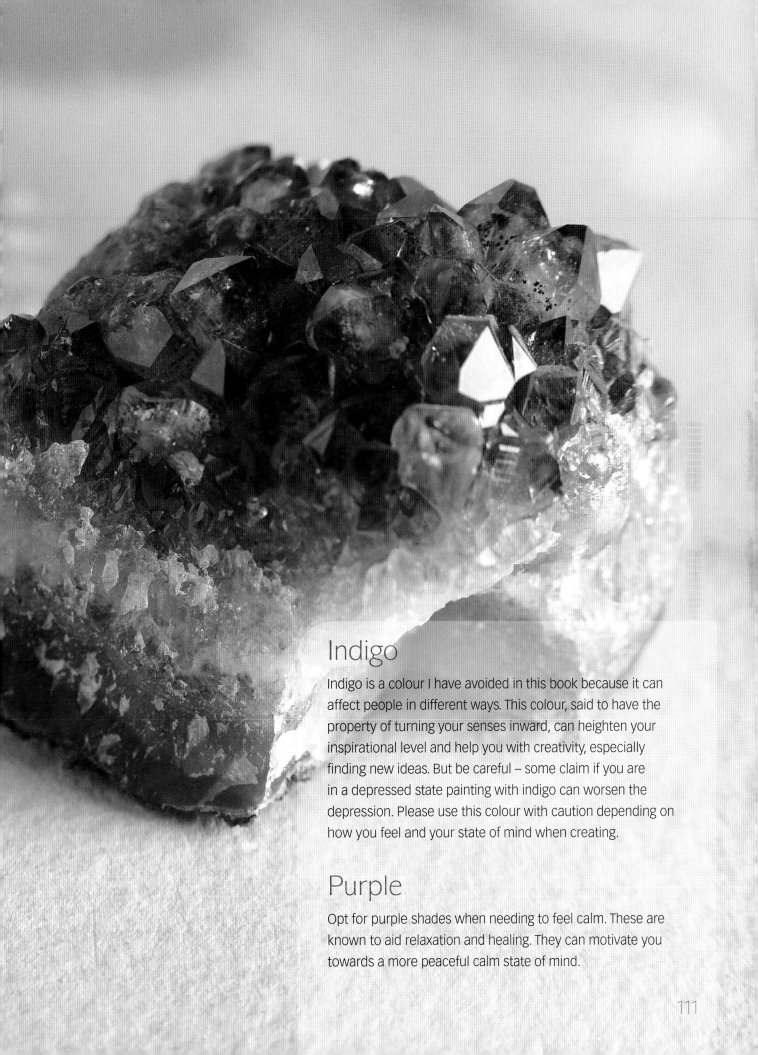

Indigo

Indigo is a colour I have avoided in this book because it can affect people in different ways. This colour, said to have the property of turning your senses inward, can heighten your inspirational level and help you with creativity, especially finding new ideas. But be careful – some claim if you are in a depressed state painting with indigo can worsen the depression. Please use this colour with caution depending on how you feel and your state of mind when creating.

Purple

Opt for purple shades when needing to feel calm. These are known to aid relaxation and healing. They can motivate you towards a more peaceful calm state of mind.

Pushing away troubles

I want you to imagine you are deliberately setting out to paint in a way that will lead you to a calm state. So every single brushstroke has to be gentle. Your touch on paper has to be soft. And you are going to will the colour to flow beautifully. If you can play calming music of your choice while you paint, that would be a wonderful addition to your painting session – unless you prefer to paint in complete silence. The demonstrations here can be painted with one shade or several.

You choose.

Please make sure you will not be interrupted. Make your painting time count.

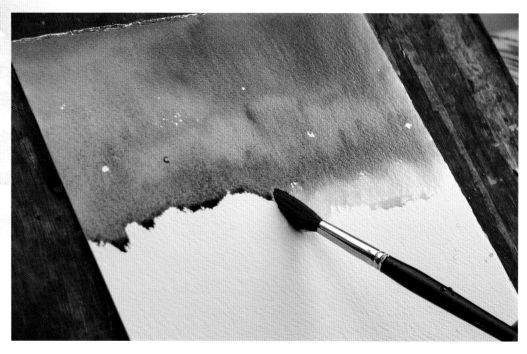

If you only add water with each new brushstroke, the band of colour you first placed will flow into the newly wet section. The colour will get lighter and lighter as you move away from the dark colour band.

Look at the white piece of paper before you start. Take in its space and freshness before you begin adding colour. Think about relaxing throughout the painting process. First you need to create a band of purple at the top of the paper which can represent how tired you are or any stressful problems you may be facing.

 Now begin to add water to lighten this colour. With a clean damp brush, begin to move the colour downwards on the paper. Imagine that, in doing so, you are lightening your mood and lessening your problems. Imagine feeling your tiredness or stress easing away getting lighter too. When you become used to painting with this train of thought, you will begin to feel stress-free more naturally.

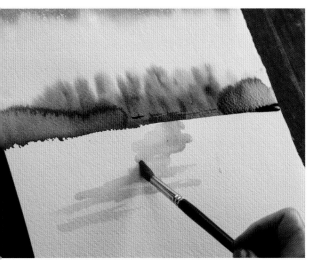

Next you can paint a horizon line. Where you place this will be a personal decision. It can be halfway down the paper, or nearer the bottom or top. You have control. You decide. Believe in your decision. Whatever you do, remember that you cannot make a mistake as there are no rules. This is playing with colour simply to relax. Keep the paper above the horizon line slightly damp with clean water. Now add some colour just above this line in places and allow it to merge as it touches the wet paper. It cannot move downwards as the paper below the horizon line is dry. So the newly applied pigment will move upwards into the still-wet section. This colour will blur to create soft hints of trees as if in a landscape. Leave the painting to dry, and the foreground will look like pure, untouched snow. Perfect and white.

Simple additions

Now decide. Perhaps you like this simple landscape as it is with pure snowfall in the foreground. Alternatively, you may wish to add colour to hint at a pathway, as shown in my example to the right. Whatever you choose, this is your painting, created simply to relax into a purple peaceful calm zone.

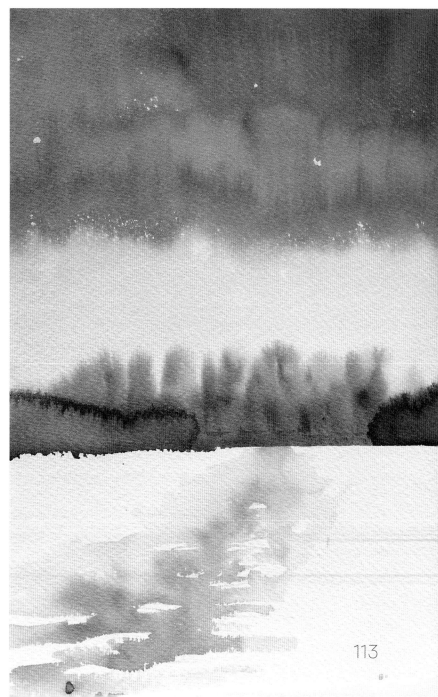

113

Relaxation when painting

There are many subjects and ways to paint to help us relax. You can paint anything at all with violet shades – there is nothing to stop you painting a purple sunflower or poppy, for example. The joy of painting to feel calm is about just that, the joy of creating without rules or limitations. Once your imagination is open to the idea of painting to change your mood or aid relaxation, creating as a way to pass time can take on a whole new meaning.

Of course you can choose to paint a variety of wonderful subjects, but if the aim of using colour is to feel calm, it is vital that you take your time when painting and that the experience remains stress free. Learn to enjoy and use colour so that it benefits you within. Learn to have confidence in yourself and your ability. It may be more easily said than done, but learn to relax when painting. Aim to let go and be free. Most importantly, feel calm, peaceful and rested after every painting session.

Bear in mind that once you reach a sense of wellbeing, it is wise to avoid immediately racing to do something else. Make a point of staying relaxed and rested. Take a few minutes to simply enjoy the feeling. When you close your eyes at the end of the day, you might imagine being surrounded by healing violet. Allow your mind and body to rest.

Rest is something we all need, and quality healing time to recharge our batteries is vital to our personal wellbeing. Rest with visions of healing violet, and look forward to your next relaxation painting session.

Each time you pick up your brushes make a choice and try to remember what the benefits of working in each colour are.

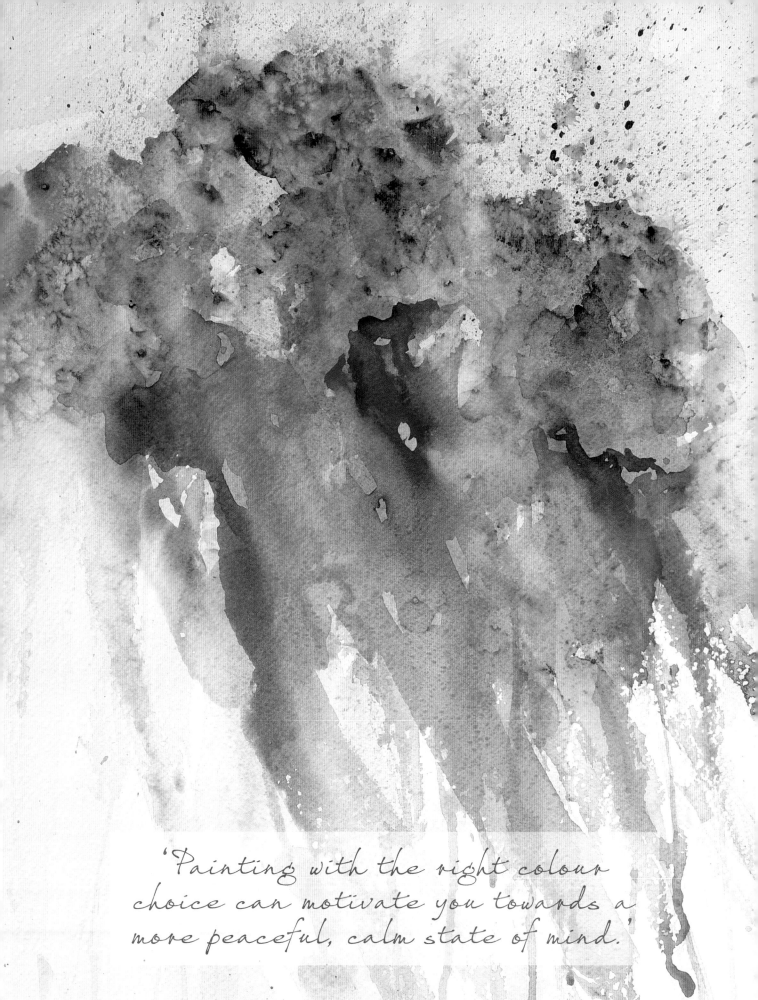

'Painting with the right colour choice can motivate you towards a more peaceful, calm state of mind.'

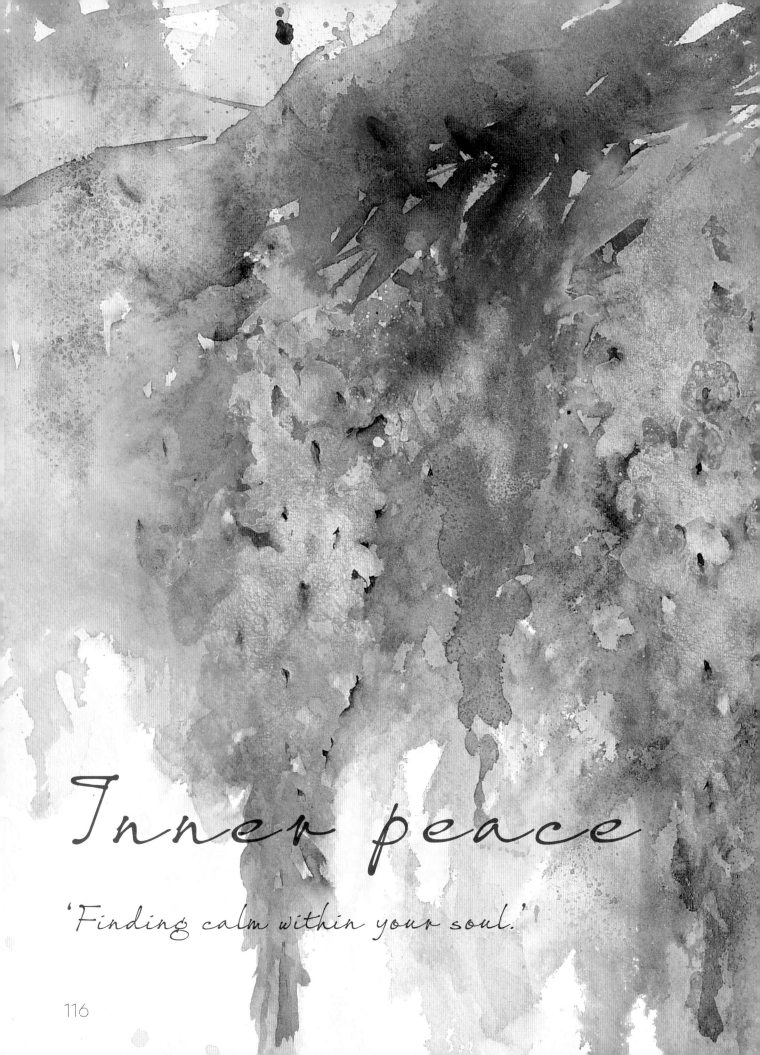

Inner peace

'Finding calm within your soul.'

117

'We all deserve to feel happy and we all deserve time to ourselves to simply enjoy life.'

That peaceful feeling

Throughout this book we have looked at ways to work in watercolour to relax by using thought processes and colour to aid our sense of calm. Just by moving a brush we have discovered it is possible to change our mood, or temporarily escape to a peaceful haven where only we exist.

Over the centuries, art has been used to record history, capture memories, tell stories, and most of all, for the pure pleasure of creating. Using painting to achieve a healthy state of mind and sense of wellbeing is an art form in itself. Recognising this as fact is possible with very little effort. What is needed to relax with colour is time and a little knowledge. The pages of this book share ideas, but it is up to you, the reader, to find a way to paint that is of most benefit to you as an individual. You will know what your favourite subjects and colours are. You alone will know how to make the most of each individual exercise, in a way that suits you and aids you best.

I know from personal experience that there have been times in my life when I do not feel I could have coped had it not been for my ability to use colour, with or without my brushes. Time helps and heals, so they say. I believe colour can too. I use reds and oranges to feel more energised on days when I am so exhausted that I need to recharge my batteries. At times when I need to unwind, I turn to the peaceful blues and violets. Painting isn't always solely about colour and how to use it – it is the thought process behind each painting session that is more important and which stays with me long after I have put my brushes down. When needed, I revisit my paintings in my imagination by visualising colour flowing. The interaction of colour and water alone is relaxing, so watching and taking time to do so is can be very rewarding.

There is a kind of healing magic in the peaceful feeling attained by being at one with a brush; an achievement that many believe only professional artists can attain and even then only at a high level of their professional careers. But if that were true, children with no artistic training at all would be unable to feel a sense of pleasure from creating. We do not have to be masters to paint. When we create we do not always have to achieve incredible masterpieces that can be framed. Each of us has the ability to move a brush and choose colours to make our painting time extremely enjoyable. When doing so, if we place the emphasis on colour alone and the action of it combined with water, we can find relief during the process and in turn improve our lives.

I am so content because of the way I use colour to improve my life. I would love to say that nothing phases me but if it does, I know that painting simply and calmly can get me through bad times, no matter how awful they are. We all deserve to feel happy and we all deserve time to ourselves to simply enjoy life. By making time to paint, we can calm our state of mind and relax.

Life experiences

'Art can be healing in many ways.'

Painting can affect us greatly – and does. I know because I am constantly meeting amazing people in my workshops; people who tell me how art has changed their lives. Painting has changed mine, both by helping me to relax, and because I now accept invitations to teach watercolour workshops all over the world. When I look back to the very shy child I once was, I find it hard to believe I can now stand in front of an audience of over two hundred people and feel calm purely because of my passion for painting. I paint in a very soft style that is relaxing. It is this feel-good relaxation technique when I am painting that everyone enjoys most about my demonstrations. But this book is not just about me, how I feel when painting or how watercolour has changed my life. I am aware that the way in which colour has changed my life can be and has been felt by others. Rather than share my own experiences I would like to share a story which is true and has touched many hearts.

On one of my tours of the USA, I had started teaching in California. After teaching there, I travelled to my next destination, Lewisburg in West Virginia, before moving on to teach in St Louis and New York. I should explain that my popular workshops are sold out up to two years in advance both in the UK where I live and internationally. So it has become well-known and accepted that my courses are very difficult to get a place on. Two people had both tried unsuccessfully to get on any one of my workshops for some time. They didn't mind where the location was, they just badly wanted to attend. Both had finally managed to secure a place in Lewisburg and waited patiently for the year to arrive when they could attend. When they arrived neither knew each other or had met before. They entered the room with the rest of the class and ended up sitting almost side by side, as strangers. There was great excitement in the room as I entered and I knew this was going to be one of those courses

that you never forget. But little did I know one of the reasons why it would be. You see, these two artists had a connection that neither of them knew about and it was one that was shared with the class when the time was right. I am now sharing it with you.

These two strangers, when introducing themselves to each other, realised they had both lived in the same town at the same time. One still lived there and mentioned they worked in a hospital. The lady listening replied that she knew the hospital well, as she had spent a great deal of time there before she had moved away. When she was asked why she had visited the hospital so much she went on to explain that she had sadly lost her granddaughter there, a little girl of two who had bravely but unsuccessfully fought an illness. There was silence at first but when the conversation continued she was asked,

'Was it Joey?'

Out of all the workshops they could have been on, these two strangers were sitting side by side. One was the grandmother of the little girl, the other was the intensive care nurse who had helped look after the sweet little child. Both had turned to art to help as neither of them could find healing closure. Emotions overcame the two as they were united in their grief for a child who was so loved. Imagine these two people finding each other by coincidence on a workshop and then sitting so close to each other – and why were they there? They had both found a way to ease their loss and pain through colour and brushwork. The week they were united at my workshop it would have been little Joey's birthday. I like to think that little girl may have been smiling down from heaven when they met. When I eventually told the whole group, we were all emotional. Art can be healing in many ways. Everyone hugged the two who needed to be there and have kindly given me permission to share their story – one I will never forget.

I meet so many people dealing with so much on my art courses. They all use art as a way to overcome obstacles in life. I often meet people who are dealing with cancer. One memorable lady came to see a demonstration of mine in Seattle. She asked before I began my presentation if I would agree to have my photograph taken with her. I said, 'Of course.' Her friend, who had come with her, told me quietly that Judy had changed her chemotherapy appointment and had treatment that morning rather than miss seeing me paint. She had looked forward to meeting me for so long and she was not going to let anything get in the way. How brave and amazing. She told me that my style of working in watercolour had helped her

through a terrible time and I felt so humbled to meet her. I painted a rose as part of my demonstration and explained to the audience watching that it would not be for sale at the end of my talk. Instead it was to be given to a special lady in the audience. It was, and the room felt full of love. My painting now hangs framed in Judy's home and she has sent me a photograph. She loves it. Whenever possible, I now give away a rose painting in her name and I hope she will like that idea. A simple painting can hold so much love in it and make someone feel so differently by looking at it. But the inner calm felt when relaxing via moving the brush and watching colour move should not be underestimated.

'A simple painting can hold so much love in it.'

On another occasion I met an incredible lady who lived on Long Island. I was taking a workshop at the time when Hurricane Sandy hit. I remember being stranded in a hotel for days, waiting for a flight home. But that was nothing compared to the devastation many people endured during that time. This particular lady lost her home and everything in it due to the terrible storm. I sent her some art supplies, not even realising that she may not even have space to paint, but when we reconnected she told me my kindness had helped her. She is such a fantastic lady and she now teaches art and watercolour too, helping others enjoy painting as much as we do – because painting helped her get over her ordeal and sense of loss.

An architect once let me know that, as a man who could previously only paint fine detail, his life had changed after attending one of my workshops. He told me that he hadn't known how to relax before and that he felt like a new man with a completely new life ahead of him. How wonderful is that?

People find art therapeutic for many reasons. Painting has helped them through so much and yet there is still a notion held by some that painting is only for those who know how to paint. I truly hope that this book shows how anyone and everyone can paint, and by doing so find inner peace and calm.

A positive attitude

'Painting can help us look forward with a positive attitude.'

Seasonal changes

I love the change of seasons as each arrives. I adore summer as my garden is full of beautiful flowers then – mainly because my husband and I work so hard in it. All the effort is so worthwhile when we see the plants flourish.

In life everything we do takes effort – even relaxing. We have already discussed that making time to replenish our energy levels and calm our thoughts is vital to a healthy way of life and acts as an aid to our personal wellbeing. I view relaxing via painting as a way to renew the soul and take a step back from everyday life.

Seasons can affect our mood, particularly in cases of Seasonal Affective Disorder (SAD), a type of depression. The symptoms of SAD can include a marked lack of interest in normal everyday activities, but these symptoms can be alleviated and even disappear in brighter months. Imagine being able to bring sunshine into our lives whenever we wish, improving our mental state simply by creating with warm glowing colours that represent sunshine. Painting can help us look forward with a positive attitude.

And we can learn from nature.

Enjoy the simple things in life

Springtime
12 x 18cm (4¾ x 7in)

Enjoy the simple things in life. Take time to observe nature throughout the year. Discover new colours to work with and new things to paint as the seasons change.

Try to keep a positive attitude

Try to keep a positive attitude at all times, even when things are getting you down. Painting with vibrant glowing colour can ease stress, act as a distraction and boost your morale. Think about painting as a way to move forward in a happy, calm state of mind.

Make painting a part of your routine

Never be afraid to take up a new hobby to try your hand at a new skill. As life passes, set a challenge to try something new each year that benefits only you on a personal level. Decide to put yourself first at least once a week: make time to paint and be in control of how you feel while creating. Choose colours that you need to relax and enjoy relaxing.

Begin to see painting as part of your daily routine and use it as a way to improve your mood. You deserve to. You count – and you can do this. Take control of how you feel by using colour positively.

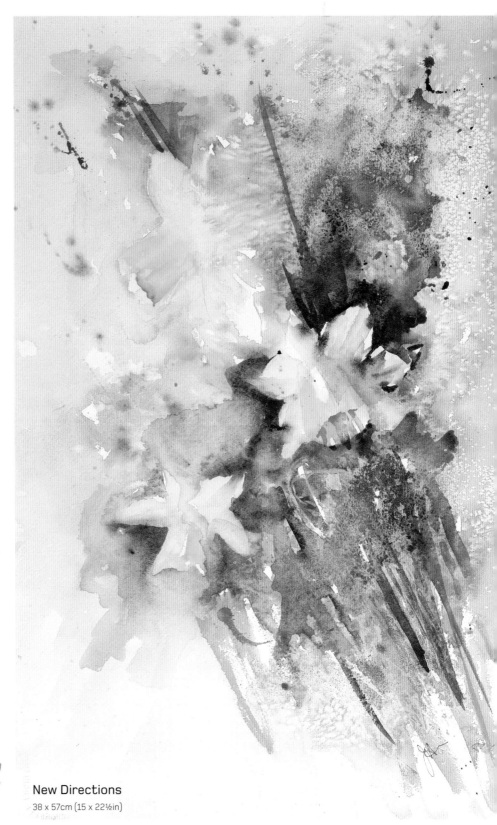

New Directions
38 x 57cm (15 x 22½in)

Spring Medley
23 x 39cm (9 x 15¼in)

Finding freedom through art

Take time to think about what you want to achieve. Give yourself a few goals that will improve your life. Decide when you are going to paint. Decide how you are going to make the most of the exercises in this book and understand that there may come a time when you want more from painting.

You may feel then that you can use the techniques from the colour exercises you have practised to paint more complex scenes. This can then lead to frame-able paintings, but never lose sight of the fact that painting can be relaxing. If ever you reach a stage when creating becomes a chore or is more stressful than it is relaxing, take a deep breath and go back to the beginning of this book. If you are already an artist who has lost the sense of freedom when creating, again, work through this book taking your time and re-evaluate what art is about for you – and why you are painting in the first place.

You count.

You can paint yourself calm

...and enjoy doing so.

Index